IMAGES
*of America*

# HATBORO

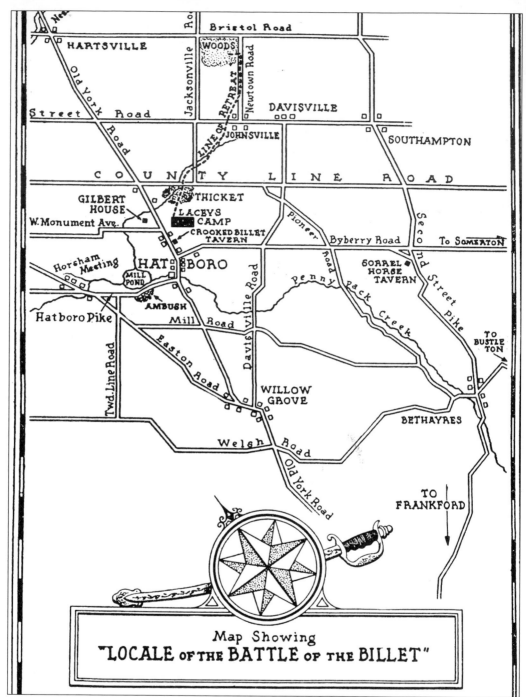

Map Showing
## "LOCALE of the BATTLE of the BILLET"

**BATTLE SITE.** Young Brig. Gen. John Lacey of Bucks County was assigned by Gen. George Washington to the almost impossible task of using his 60 to 300 men to harass the much larger British force. His detachment had fluctuated in number and had dwindled when he was surprised and surrounded on May 1, 1778. Nearly 30 men, mostly from York and Cumberland, died in the skirmish. Lacey and the rest of his command escaped north into the Bucks County woods, which Lacey knew much better than the British did.

IMAGES
*of America*

# HATBORO

The Millbrook Society
with the Regenhard Collection

ARCADIA

Copyright © 1999 by The Millbrook Society
ISBN 0-7385-0342-8

First published 1999
Reprinted 2000, 2001, 2003, 2004

Published by Arcadia Publishing,
Charleston SC, Chicago IL, Portsmouth NH, San Francisco CA

Printed in Great Britain

Library of Congress Catalog Card Number: 99-69057

For all general information, contact Arcadia Publishing:
Telephone 843-853-2070
Fax 843-853-0044
E-mail sales@arcadiapublishing.com
For customer service and orders:
Toll-free 1-888-313-2665

Visit us on the Internet at www.arcadiapublishing.com

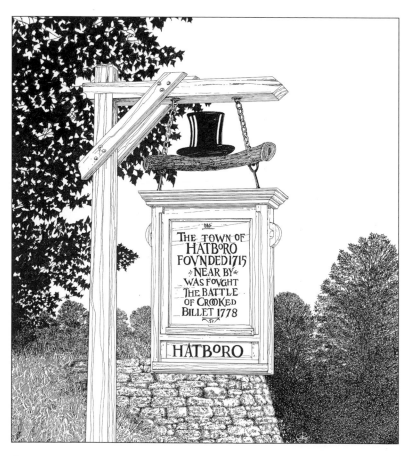

(Illustration by
John I. DeFabio.)

# CONTENTS

Acknowledgments and Bibliography                                          6

Introduction                                                             7

1.    South York Road: North to Byberry Road                              9

2.    South York Road: Byberry Road to Moreland Avenue                   39

3.    North York Road: Moreland Avenue to the County Line                75

4.    Secondary Streets of Hatboro                                       93

5.    Willow Grove and Horsham                                          111

6.    Bucks County: Warminster, Johnsville, Warwick,
Hartsville, Davisville, and Southampton                                 119

# ACKNOWLEDGMENTS AND BIBLIOGRAPHY

Proceeds from the sale of this book will be used for the purchase of a historic property in Hatboro.

Special thanks go to several people who have worked diligently to make this project a success: Jack Regenhard, project director; Dave Shannon, executive director; Gerald D. Ames, Mary Van Pelt, Ron Beifus, Mary Porter, Jane Poole, Frank Sorace, Beverly Blackway, Ann Regenhard, and members of the Millbrook Society who contributed in any way, shape, or form. Special thanks go to John I. DeFabio for the illustration of the Hatboro sign.

Among the sources appreciatively utilized for this book are:

Bailey, Paul. *History of Warminster.* 1970.

Bean, Theodore, ed. *Montgomery County: The First Hundred Years.* 1884.

Davis, Betty. *The Arnold Brothers of Bucks County.* 1980.

Eynon, Thomas. *125 Years of the W. K. Bray Lodge in Hatboro.* 1993.

*Historical and Business Directory Hatboro, Pennsylvania.* Old York Road Publishing Co., Hatboro, Pennsylvania. 1930, 1936, 1940, 1943, 1954.

*History of Hatboro—Public Spirit Newspapers.* May 10, 1986.

McGuigan, Sharyn C. *Reflections of the Hatter...John Dawson.* 1988.

Pinkerton, Sarah. *The Story of Hatboro: 250 Years in Review.* 1955.

————— *Battle of The Crooked Billet—Official Program.* 1928.

Smith, Charles Harper. *The Settlement of Horsham Township.* 1975.

————— *Colonial Land Tenure in Hatboro and Vicinity* (a bulletin of the Montgomery County Historical Society.)

Toll, Jean Barth, and Michael J. Schwager, ed. *Montgomery County: The Second Hundred Years.* 1983.

While historical integrity is a manifest part of a historical society, brevity for the purpose of this work restricts our explaining of some clarifying details. We do welcome any comment, story, fact, or material the reader may wish to share with us.

# INTRODUCTION

As with the pictorial history of any town, the compiler must present a short account of the community's early years, before the advent of photography. Hatboro's history predates its photographic record by many years. The following is an overview of the history of Hatboro from 1700 to the present.

Hatboro, also known as Hatborough and Crooked Billet, is the only town so named in the United States. For years it was generally believed that Hatboro was founded in 1705 and first settled by John Dawson. However, recent research has shown that the land where Hatboro is now located was purchased on a warrant from William Penn by the family of Nicholas More. The Mores did not begin subdividing the land until after 1705. The first available record shows that Lawrence Thompson received title to his land in 1711 and that in 1715, he built his home, a log house, at what is now Moreland Avenue and York Road. Thompson was followed by Emanuel Dungworth, a miller, Isaac and Jeremiah Walton between 1715 and 1717, and lastly by John Dawson between 1717 and 1719.

While John Dawson was not the first settler in the area now known as Hatboro, he was the most instrumental in founding the town. His occupation as a hatter or felt maker accounted for the present name. Another name that was given to the area, Crooked Billet, can also be traced to him. John Dawson arrived in the province of Pennsylvania from England in 1710. He seems to have lived and worked in Philadelphia from 1717 or 1719, purchased lots in the future borough, and moved his family there in 1719. Sometime in 1734, he built a third home on the east side of York Road between Moreland Avenue and Byberry Road. He operated his hat manufactory there and entertained paying travelers for overnight stays as well. While he was proprietor, this building was a "house of private entertainment," not a tavern, as no record of his ever holding a tavern license exists. He called the place the Crooked Billet Inn, after the famous tavern of the same name on Water Street in Philadelphia. By 1735, Hatboro was a thriving settlement with a gristmill, blacksmith shop, and two taverns, in addition to John Dawson's establishment. It also boasted a doctor and an undertaker, who was also a cabinetmaker.

A 1749 Scull map of Pennsylvania simply refers to the settlement as the "Billet." Lewis Evans published a map of Pennsylvania and called the community Hatboro' (sic). In 1809, when the post office opened, the official name was Hatborough. Postmaster General John Wanamaker in the 1880s changed it to the shortened version to save space on cancellation marks.

In 1755, a group of men banded together to form the Union Library Company of

Hatborough, which was the third library company to be founded in Pennsylvania. It still serves the community as a public library, and in its original building. In 1777, Gen. George Washington and his army passed through the borough several times as they traveled up and down York Road in pursuit of the British. In May of 1778, an action known as the Battle of Crooked Billet was fought in and around the community. In 1811, the Loller Academy was built and opened its doors to students in 1812. The academy, together with the Union Library, the public school, the Young Ladies Seminary, and the Young Men's Institute established Hatboro as the educational center of an otherwise rural area.

Hatboro was incorporated as a borough and acquired its first bank in 1873. The railroad came through in 1874. The trolley came to Hatboro with the founding of the amusement area, Willow Grove Park, in nearby Willow Grove.

Early in the 20th century, musician-composer Victor Herbert visited often in Hatboro during the summers, while his orchestra played at nearby Willow Grove Park. He worked on two of his operettas, "Babes in Toyland" and "The Red Mill," while in the borough. John Phillip Sousa also played at Willow Grove Park, and many of his band members lived in the lower hotel while in the area.

Hatboro developed and acquired industry but from its founding through 1915, its population never rose above 350. The coming of World War II brought a great change. Brewster Aviation in Warminster, a manufacturer of light bombers, and the Willow Grove Naval Air Station in Horsham brought large numbers of people to the area to support the war effort. At the end of the war, many chose to stay. The population had exceeded 7,000 by then and has remained at about that level ever since. Hatboro's influence as a commercial center fell on hard times with the advent of the shopping mall, but its educational strength never flagged.

With the coming of the new century, there has been a revitalization of the business center of Hatboro. This includes participation in the Main Street Manager program and other events, such as the Moonlight Memories Car Show and the Hatboro Arts Festival. Many new restaurants and shops have opened their doors again to attract people to the borough.

The images reproduced in this book are a sampling of the Millbrook Society archives of images portraying people, events, organizations, schools, businesses, and homes in and around Hatboro, Montgomery County, Pennsylvania. The society is the official historical organization for the borough and school district. The archives contain over 18,000 images covering the period between 1800 and the present. The majority of the images are of Hatboro and the surrounding communities of Horsham, Warminster, Southampton, and Upper Moreland (Willow Grove). Other areas are represented in the collection and are useful in our educational outreach. All images have been donated by the residents of the area or have been acquired by the society from other sources, such as the *Public Spirit* newspaper and postcards. Additional material is constantly being acquired and preserved.

We hope you enjoy this work.

—*David Shannon*
*Hatboro historian*

# One

# SOUTH YORK ROAD

## NORTH TO BYBERRY ROAD

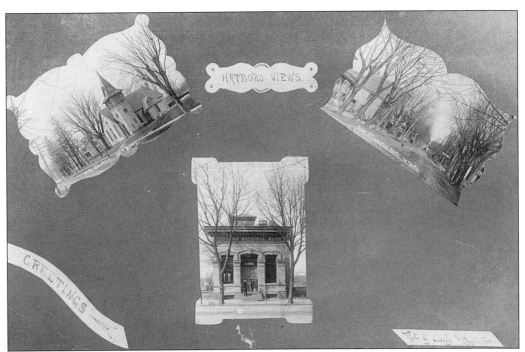

**HATBORO VIEWS CARD.** The early-1900s views on this postcard show, from left to right, the Lehman Methodist Church, the Hatboro National Bank, and York Road north. The card is known as a "multi-views" postcard, which was very popular to send to friends and relatives to show them scenes of your town.

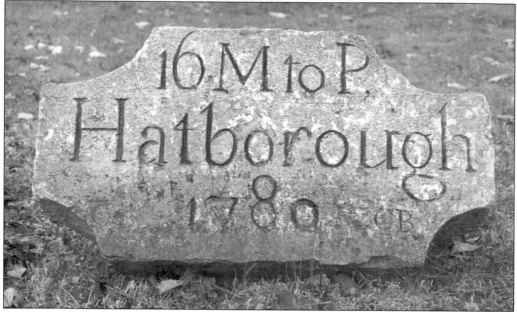

**A STONE MILE MARKER.** This marker, dated 1780, sat beside York Road, stating that it is 16 miles to Philadelphia. It is estimated that it may have been near the south borough line on South York Road, as a similar stone marker reading "15 M to P" was documented to be very close to the current Pennsylvania Turnpike overpass. This is one of various types of markers used along many of the roads and pikes in our early history. A road, particularly a toll road, had a marker every mile, as did many railroads.

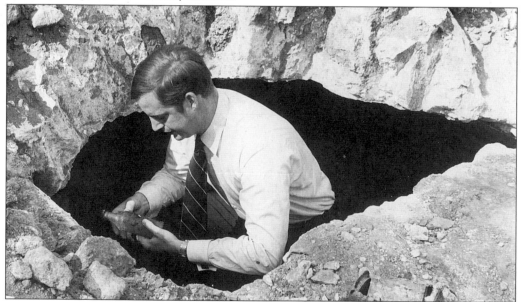

**THE YMCA ROOT CELLAR.** During the early part of the 1800s, the building used as the Hatboro YMCA, originally the Honorable Nathaniel Boileau Home, was a stop on the Underground Railroad. When the YMCA broke ground for an outside pool, it discovered an underground chamber filled with artifacts, indicating that the room was once used to hide runaway slaves. This picture shows Hugh Miller looking at some of these artifacts.

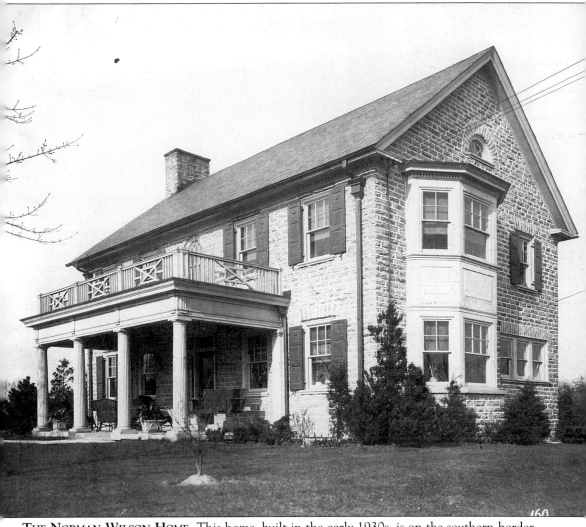

**THE NORMAN WILSON HOME.** This home, built in the early 1930s, is on the southern border of Hatboro below Mill Street. It was the home of the late Norman Wilson, a former mayor of Hatboro.

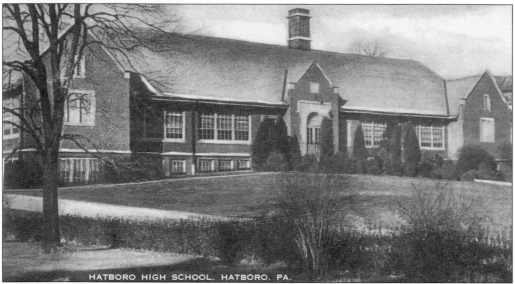

HATBORO HIGH SCHOOL, HATBORO, PA.

HATBORO HIGH SCHOOL. This school was built on York Road south of Horsham Road in 1927 with an authorized loan of $45,000. Hatboro High School's 160 students moved into the new facility, and additional curricula came with that move. Initial construction was followed by the addition of an industrial arts building in 1930 and a gymnasium nine years later. The building served briefly as a junior high school in the late 1960s due to an influx of population. It currently is the home office of Penn Independent Corporation.

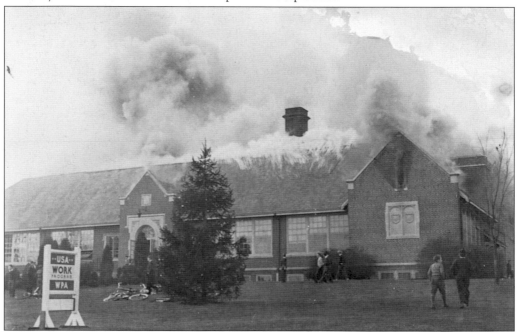

HIGH SCHOOL FIRE. In 1939, fire damaged the high school on the west side of York Road, south of Horsham Road. The building was repaired and still stands today. Note the sign out front advertising work opportunities with the Works Project Administration (WPA), a U.S. government program established after the Great Depression. The building was used as a private business in the late 20th century.

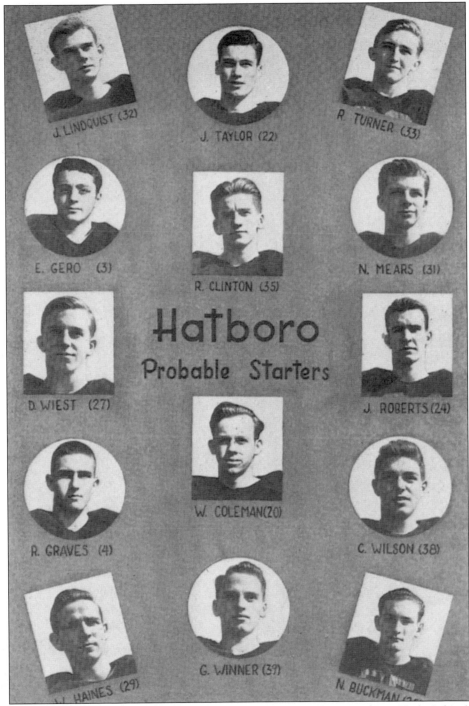

**HIGH SCHOOL SPORTS.** Enthusiasm for sports was always high at Hatboro High School, but nothing compared to the Thanksgiving football game. Hatboro's arch rival was Upper Moreland High School. Special pep rallies were held in the auditorium weeks before the game took place. Program booklets giving the names of all of the players were printed up for sports events, such as this 1945 game.

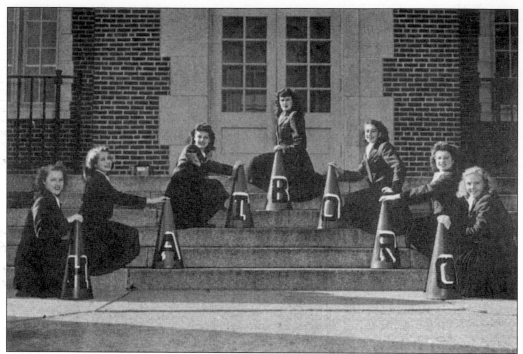

**HIGH SCHOOL CHEERLEADERS.** The cheerleaders generated cheers to rally the students, and school spirit reached an all-time high. Cheerleaders shown here are, from left to right, D. Valentine, L. Kraiser, M. King, B. Schneider, A. Keeble, D. Connery, and M. Park.

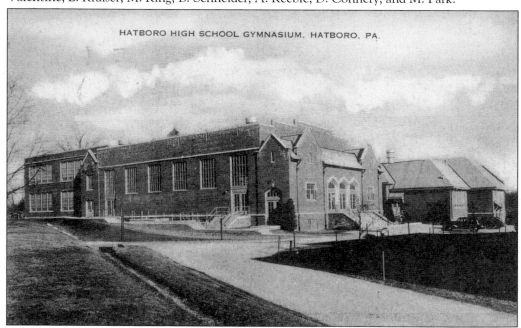

HATBORO HIGH SCHOOL GYMNASIUM. HATBORO, PA.

**HATBORO SCHOOL ADDITIONS.** This picture is a rear view of the Hatboro High School constructed in 1927. It shows the additions that were added during the 1940s, which included classrooms, an auditorium, and a gymnasium. The music department was in the building to the far right, out of the picture.

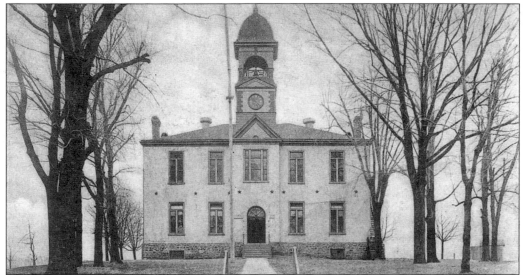

**THE LOLLER ACADEMY.** Robert Loller (1740-1808) was an educator, surveyor, and courageous patriot. He fought at Trenton, Princeton, and Germantown. He was elected to the Continental Congress and helped draft the Pennsylvania Commonwealth Constitution. He left instructions in his will for another illustrious neighbor and good friend, Nathaniel Boileau, to build the Loller Academy at a cost of $11,000. The school was opened after Loller's death, closed shortly after the Civil War, and again became a state school 60 years later. The reopening of the school was aided by Robert Loller in a surprise twist: an 1850 state law required banks to advertise long-unclaimed funds, and the Loller trustees moved quickly to claim the proceeds of a previously unknown $350 deposit by Loller just before an 1808 operation and his death in Philadelphia. In the 1950s, the building was condemned as unsafe and there was talk of tearing it down. Borough residents strongly objected and voted to restore the building, which today elegantly serves as a community center, a town hall, and borough offices.

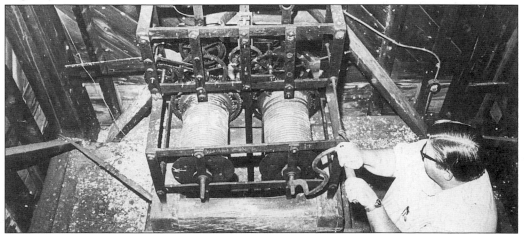

**THE ACADEMY CLOCK TOWER.** This picture shows an Isaiah Lukens clock in the tower of the Loller Academy. A seven-day clock, it has a bell in the tower above it that rings hourly. As shown , it was wound by a hand crank. The reel on the left powered the bell-ringing mechanism. This clock was installed in 1812. In 1839, Isaiah Lukens made a similar clock for Independence Hall in Philadelphia. A Horsham resident, he also was one of the founders of the Franklin Institute in Philadelphia.

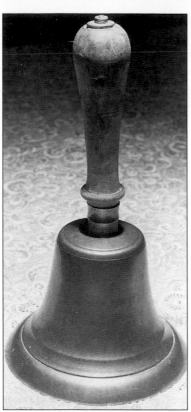

**AN OLD STORE BELL.** This bell was used to summon students to class in the Loller Academy during the early 1800s. The bell was later used by the Reading family at their general store when it served as the post office. It was rung when the mail arrived.

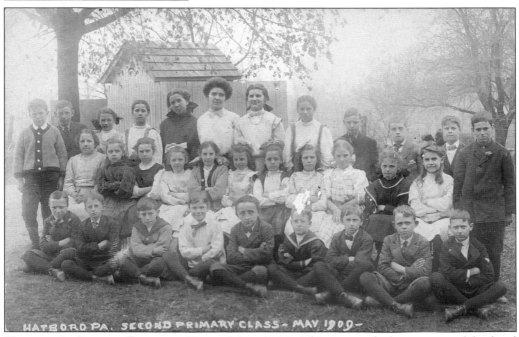

**HATBORO'S SECOND PRIMARY CLASS, MAY 1909.** This is a real photo postcard by local photographer W.H. Sliker of Bridesburg. Sliker was called to do photographs of this type for many occasions. This was one of the very few real photo postcards that he made and sold.

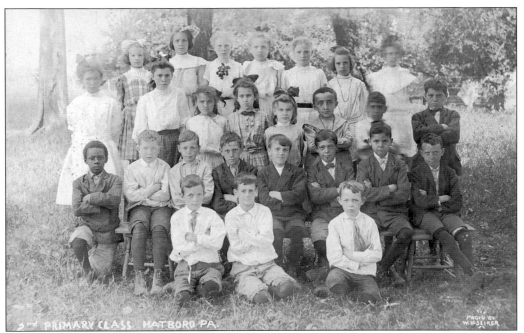

**HATBORO CLASS.** This is another real photo postcard by W.H. Sliker. The Millbrook Society is still trying to identify the students pictured here.

**HATBORO HIGH SCHOOL STUDENTS, LOLLER ACADEMY, 1906.** Shown here are, from left to right, the following students: (front row) Ella Finney, Carrie Yerkes, Anna Logan, Lara Weed, Clara Wood, Alberta Dietrie, Blanch Dawnie, Anna Finney, and Marie Yerkes; (back row) Sara Yerkes, E. Hanley, Mary Stone, Emma Hobensack, E. Walmsley, Bertha Hobensack, and E. Munch. The young people in the background are from the lower school. Notice that most of the students are female.

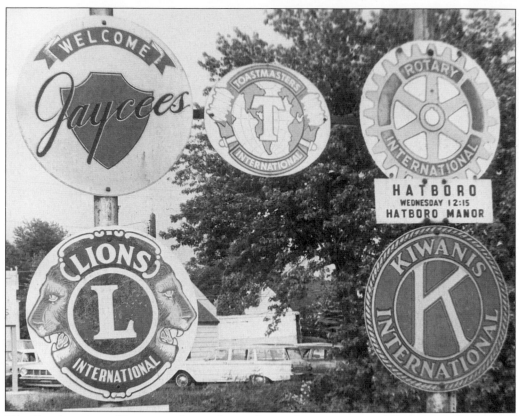

**THE ENTRANCE TO HATBORO.** Located near the southern entrance of Hatboro on York Road, these signs show the organizations that Hatboro residents and business people participated in through the 1950s.

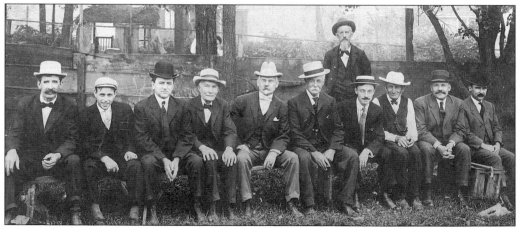

**PROMINENT BUSINESSMEN.** The businessmen seated, from left to right, are Mr. McVaugh, Rev. P. Shook, Peter Hollowell, Samuel Garner, Tom Neely, Mr. Mattis, Atwood Sterling, Paul Jones, and William Wilson. Standing behind them is Mr. Fitzgerald.

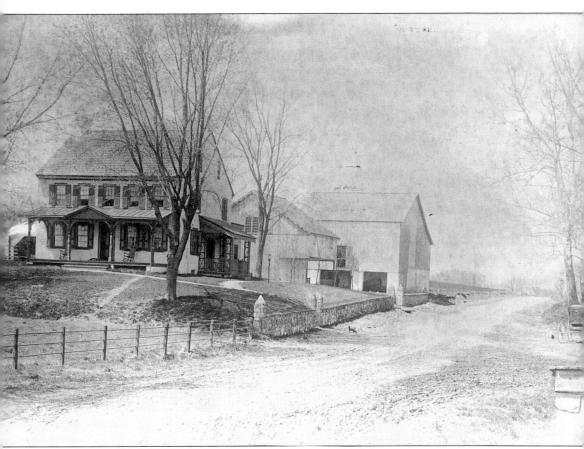

**THE PENNYPACK HOUSE.** This building was home to the miller Emmanuel Dungworth who built and ran the Old Mill on Horsham Road, at York Road. He built the mill first and then built his house between *c.* 1715 and 1725. The road in the photo, for a time known as Hatboro Pike, is still called Horsham Road today. This home still serves the mill in much the same way as it began, by housing a member of the family owning the mill, later the Old Mill Inn restaurant.

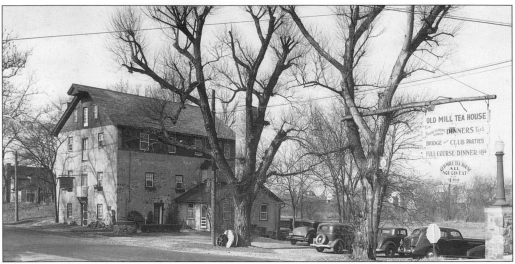

**THE OLD MILL INN.** This is the oldest structure in Hatboro. Mr. Dungworth built this mill before 1724. It may have been operating even as John Dawson arrived here, at the future site of Hatboro on the Pennypack Creek. In this picture, taken in the 1930s, the building was called the Old Mill Tea House. Notice the sign that reads, "All you can eat for $1" and the corner of the Old Stone Arch Bridge on the left. In the background are farm fields that lead up to Williams Lane. In August 1777, Gen. George Washington used this mill to grind grain for his troops, on his way to an encampment at the Neshaminy, where General Lafayette joined the army. The mill has housed a number of different businesses, including a blacksmith shop. After renovations in 1918, it opened as an eating establishment. Today, the Old Mill continues that tradition and is considered a very fine restaurant.

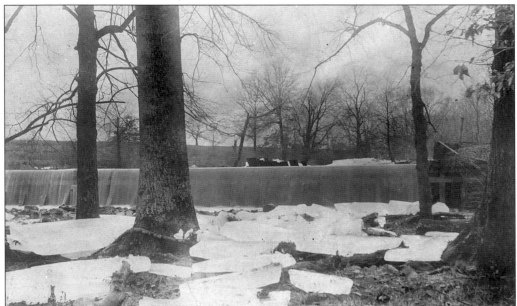

**THE UPPER PENNYBACK DAM.** This photograph shows the Pennypack Dam, which powered the Old Mill on Horsham and South York Roads. The Mill Pond behind the dam became part of the Robert Bruce Apartments. Ice was cut on this pond for use by local residences and businesses.

**THE PENNYPACK CREEK.** This creek flowing through Hatboro supplied the power for the Old Mill built in 1720. Over the years, the flow of the creek underwent many changes. A dam upstream of the Old Mill backed up the creek for a mile or more. Years later a westward flowing branch of the creek was diverted underground from the railroad station area. The creek caused flooding in the past, but today it is just a gentle stream flowing through the south end of Hatboro to join the main Pennypack below the old Pennypack Elementary School.

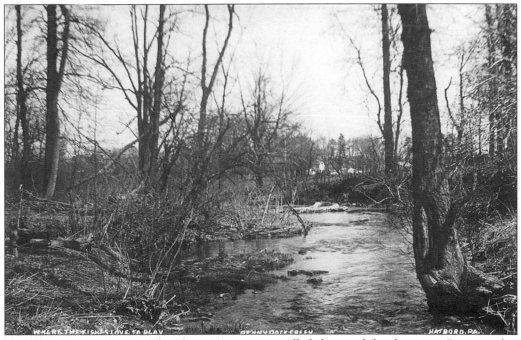

**THE PENNYPACK CREEK.** The Native Americans called this creek by the name *Pemmapecka*, taken to mean thick, muddy water.

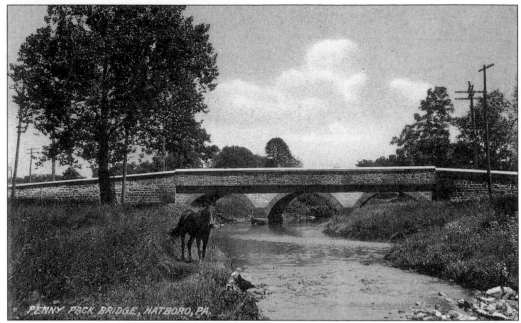

**THE PENNYPACK BRIDGE.** This is the Pennypack Bridge on York Road, which crosses the Pennypack Creek at the south end of Hatboro. This stone bridge, called the Three Arch Bridge, was built in 1824 and replaced a bridge upstream.

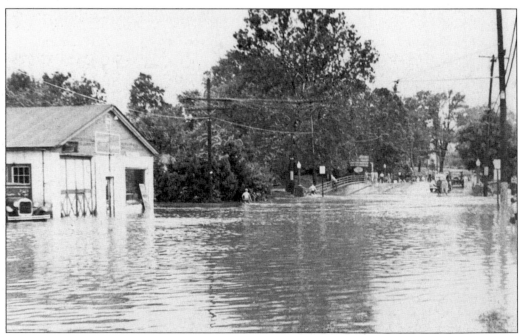

**THE 1938 FLOOD.** This view shows the flooding of South York Road on the north side of the old arched bridge, which spanned the Pennypack Creek. Most of the flooding occurred when the Pennypack tributary that flows from near the railroad station became blocked. The Pennypack Creek flooded frequently until the Army Corps of Engineers changed the creek bed in the 1980s.

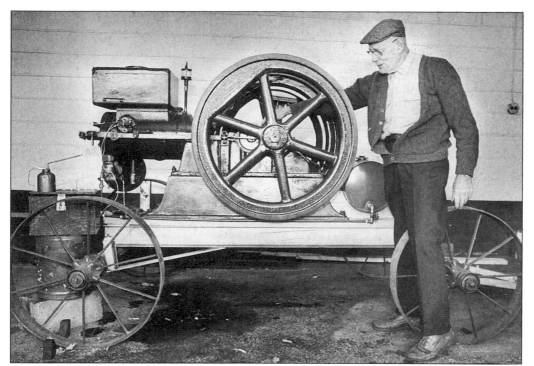

**IKE JARRETT.** For more than 50 years, Hatboro businessman Ike Jarrett owned I.M. Jarrett and Son Inc, a Dodge agency on South York Road. He also restored and collected old engines and vehicles. Here he is with a 1908, 8-horsepower Gallaway engine used for thrashing and sawing wood. Note the tank for water coolant. The business is now run by his son, Frank Jarrett.

**VAL'S POTTERY SHOP.** This shop dating from the 1940s, advertised unusual gifts for the house and garden. Its telephone number was Hatboro 0513-J. The building came into view as motorists entered town across the Pennypack Bridge on the west side of York Road. It is now the site of New Life Cleaners.

**THE PALMER HOUSE.** This home was the first frame structure in Hatboro. This photograph was taken around the time of the Civil War. The house was just below the Methodist church on the west side of York Road, above the Pennypack Creek.

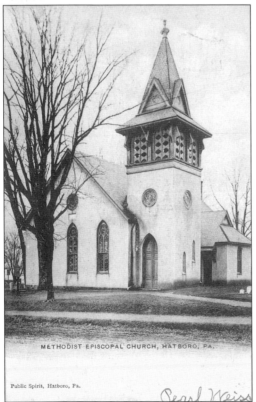

METHODIST EPISCOPAL CHURCH, HATBORO, PA.

Public Spirit, Hatboro, Pa.

*Pearl Weiss*

**METHODIST EPISCOPAL CHURCH.** As a memorial to their only son, who drowned in the Neshaminy Creek, Mr. and Mrs. Joseph Lehman of Philadelphia built a 40- by 50-foot stone church for the struggling Methodist Society; it became the first church building in Hatboro. The lot was purchased for $300, the building completed for $2,700, and the parsonage constructed for $2,100. Debora Lehman was of the Society of Friends and Joseph was an Episcopalian, but their needs and those of the community met on a common ground in this memorial chapel. In 1879, after being destroyed by fire, the Lehman Chapel was rebuilt in a Gothic design with a steeple.

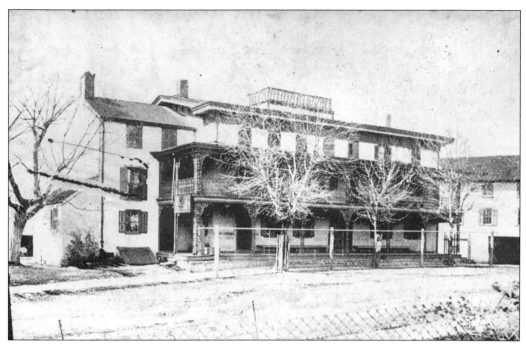

**THE JONES HOUSE HOTEL.** This is the Jones House Hotel, of the federal period, once known as the Lower Hotel. It was the very first hotel in Hatboro. It was located on the south end of York Road, on the west side. The first post office was established here in 1809. The Jones House burned down in the late 1800s and was replaced by the Hatboro Hotel.

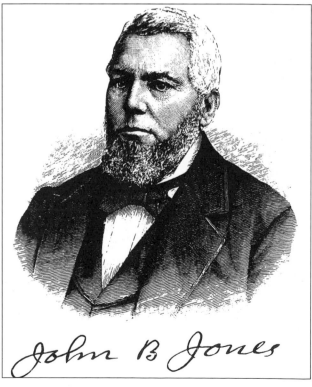

**JOHN B. JONES.** John B. Jones was a stagecoach driver, born in Worchestor County, Maryland, in 1825. In 1845, he drove the stage between Philadelphia and Easton. In 1852, he purchased the Swift Sure Line and became the contractor of mail delivery for the United States. He settled in Hatboro in 1858 and in 1860, he sold his interest in the stage line. In 1861, he bought the Lower Tavern from Robert Radcliff and then renamed it the Jones House. He ran it as "one of the best appointed hotels in Montgomery County."

25

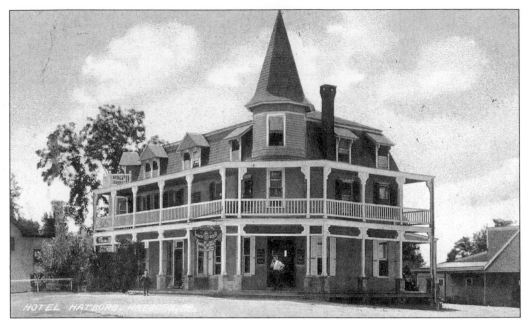

**THE HATBORO HOTEL.** The Hatboro Hotel was also known as the Lower Hotel, in part because it was south of the town center and also to differentiate it from a later-built Upper Hotel. It was built in the early 1800s after the former Jones House, (Harvey's Tavern) owned by stage driver John B. Jones, burned to the ground. The hotel was razed in 1939, 25 years after this photograph was taken in 1914. This site was also the home of Al Wilson Pontiac and currently houses a collision and body shop.

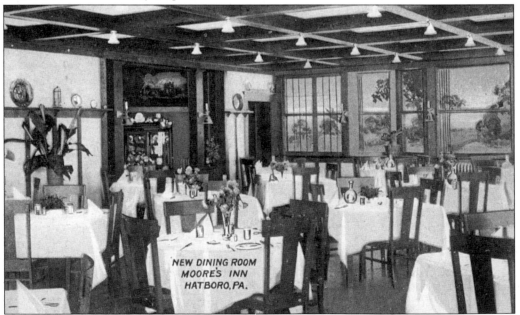

**MOORE'S INN.** This was a fashionable dining place in the early 1900s. The inn was situated on Old York Road, 2 miles north of Willow Grove Park. It was 14 minutes by trolley from Willow Grove. The telephone number was Hatboro 11. Moore's Inn later became the Hatborough Hotel. This card bore a 1920s postmark.

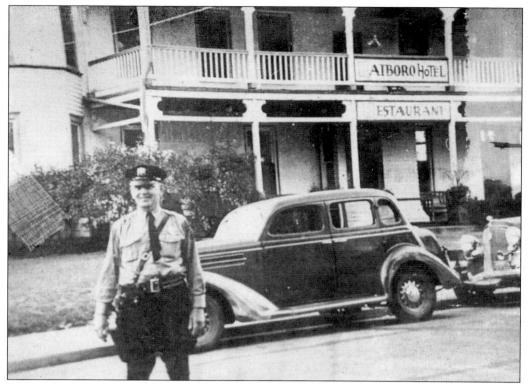

**POLICE CHIEF CHARLES FOSTER.** Charles Foster stands in front of the old Hatboro Hotel on South York Road, across from the Union Library. This building housed the first post office in 1809. Foster joined the police force in 1937 and retired in 1956. This picture was taken in the late 1930s.

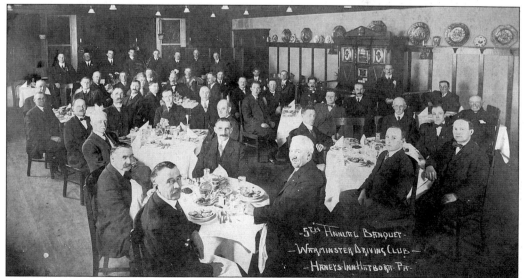

**THE WARMINSTER DRIVING CLUB.** The farmers and residents of Hatboro and surrounding areas loved their horses and formed what was called a driving club. These men drove not only buggies but also sulkies for racing. This is a photograph of one of their banquets in Hatboro in 1914.

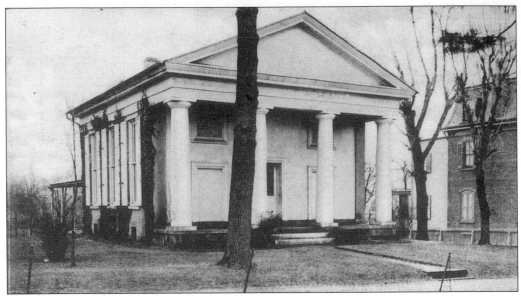

**THE UNION LIBRARY.** When the official instrument of the Union Library was founded on August 2, 1755, it was the third library in Pennsylvania and one of only eight or nine libraries in the whole 13 colonies. When the building was finally erected in 1850, it was the twelfth library building in the state. On July 19, 1955, Rev. Charles Beatty, Rev. Joshua Potts, John Lukens, and Joseph Hart met in Beatty's home and agreed upon the plan and the instrument to institute a library company. They then ordered books from London. They viewed the library as their tool to combat a "black and dark ignorance" that they saw overtaking them and their neighbors. At first, books of the library were housed in the home of the acting librarian and moved frequently and often until this building was erected. Recently, a second addition to the back of the building was being planned.

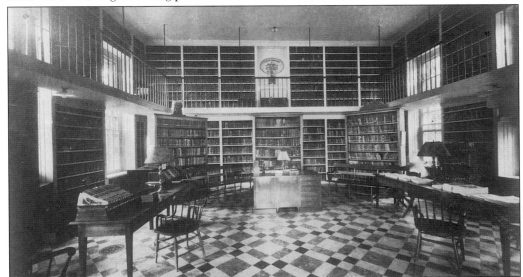

**THE LIBRARY INTERIOR.** Although the library was founded in 1755 and incorporated in 1787, the building was not erected until 1850. Until the library was built, books were kept in the home of the acting librarian. The first shipment of books arrived in 1756 from England. Many of the old books remain in the library today in a gallery that is closed to the public.

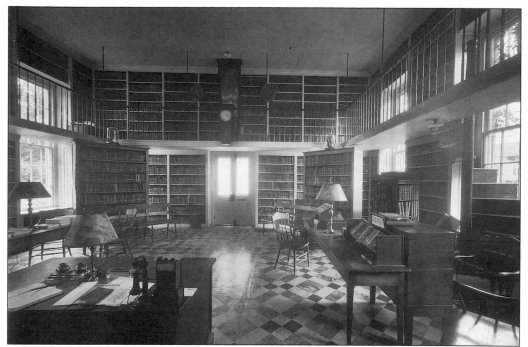

**A COUNTRY LIBRARY.** The Union Library stands on South York Road just below the Potts House, which was the first home of the Union Library Company. Joshua Potts was the first librarian. This picture shows the interior of the building in the late 1920s or early 1930s, when it was a country library, which was mainly for lending books to the community through subscription membership. It continued that way for many years, before becoming a public library.

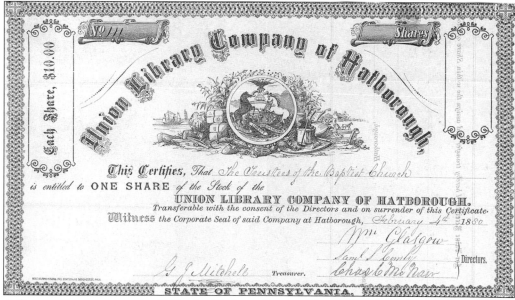

**A SHARE CERTIFICATE.** In 1880, the Hatboro Baptist Church bought a share of stock of the Union Library Company of Hatborough. This is Certificate No. 111, which cost $10. The price has not risen greatly over the years.

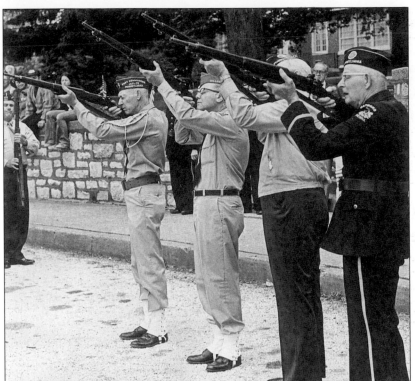

**THE AMERICAN LEGION POST.** Members of the post fire a salvo to honor the dead and to begin a Hatboro Fourth of July parade.

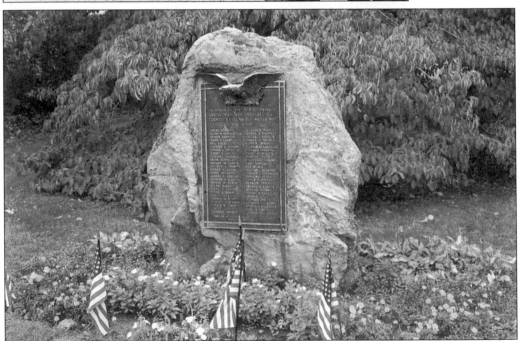

**COMMEMORATIVE BRONZE TABLET.** On May 30, 1922, this monument was erected in honor of the men of Hatboro and vicinity who answered their country's call to duty in World War I. Those responsible for its placement were headed by Warren M. Cornell, Penrose Robinson, and Dr. Thomas Reading. The stone sits on the north side of the Hatboro Library.

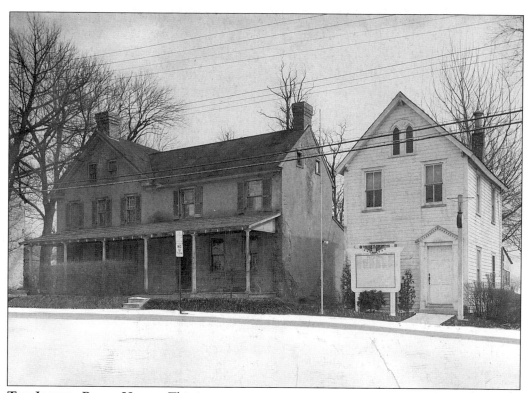

**THE JOSHUA POTTS HOUSE.** This image shows the Joshua Potts House, erected in 1743. The main, original structure is on the extreme left. The three-story stone structure facing York Road was the original portion of the building. The portion to the right was built in the 1800s. The original building had four rooms per floor and was situated on approximately 3 to 5 acres. The white three-story building is the American Legion Home, where the offices and meeting rooms were. At the time this picture was taken in 1943, this entire property, the Potts House, and the Legion Home, was owned by the local American Legion Post, the Frank Girard Post, which has since been torn down.

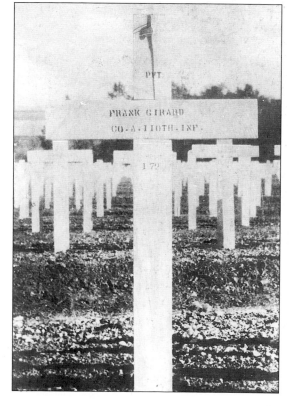

**GRAVE MARKER.** Hatboro's Veterans of Foreign Wars Post was named for Frank Girard, Company A, 110th Infantry. He was Hatboro's only son lost during WWI. This is his grave marker in France.

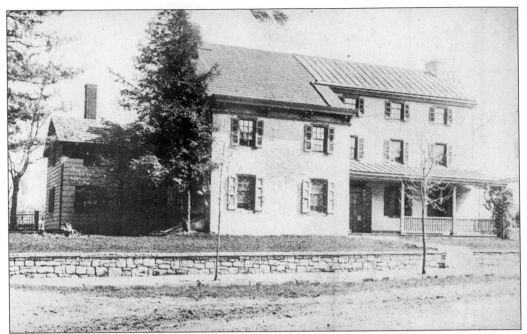

**THE HATBORO FEDERAL BUILDING.** This is a picture of the John Harrison house, which later became the Hatboro Savings and Loan building. It was built in 1741 on South York Road, north of the Union Library. In this early picture, York Road is still a dirt road.

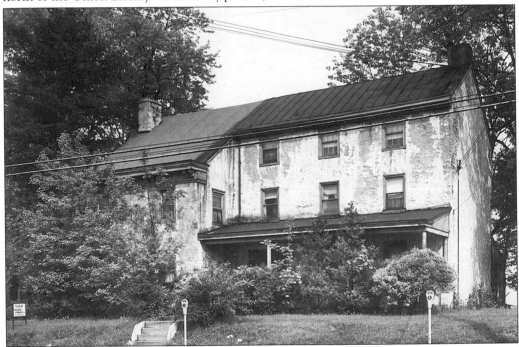

**THE JOHN HARRISON HOUSE.** This home was built by John Harrison, the great-grandson of Nicholas More. More was the man who received the original tract of 10,000 acres known as the Manor of Moreland from William Penn. This became the home of the Hatboro Federal Savings and Loan at 221 South York Road.

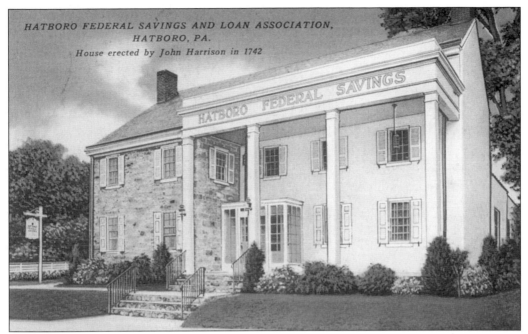

HATBORO FEDERAL SAVINGS AND LOAN ASSOCIATION,
HATBORO, PA.
*House erected by John Harrison in 1742*

THE HATBORO FEDERAL SAVINGS AND LOAN ASSOCIATION. This structure was built as a home in the mid-1700s by John Harrison. Through the years, the property changed hands 12 times before it was purchased by the Hatboro Federal Savings and Loan Association in 1950. It was then renovated for banking use, while staying within the design of its original lines.

YORK AND BYBERRY ROADS. This building was located on York Road just north of the Hatboro Federal Savings and Loan. Today, Rorer Avenue passes through the site. In this building, Hatboro Mayor Joe Celano first began his music shop in the late 1940s. Still visible are the trolley tracks that came up York Road.

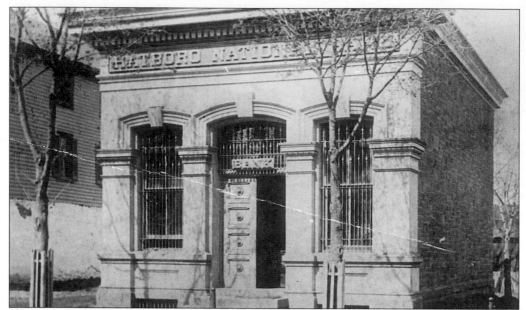

**THE FIRST BANK IN TOWN.** Built in 1873, around the time Hatboro was incorporated, the Hatboro National Bank was the first bank in town. The a native stone building with granite front veneer was later enlarged over the years in stages. Behind this building are the Hatboro Hotel stables. The building directly to the left is the Trolley Car Traction Company. Trolley cars that contained freight came up York Road, made a turn, and went in to the Traction Company building by the freight office.

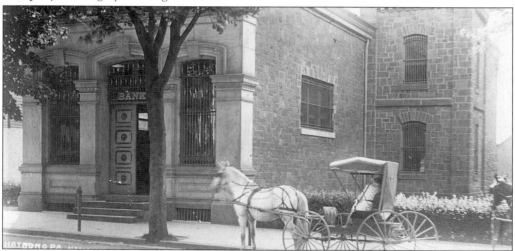

**THE HATBORO NATIONAL BANK.** S.C. Ball had previously started his first banking house called S.C. Ball and Company in a building on the northeast corner of York and Byberry Roads. He advertised widely in the *Public Spirit*. Later, he moved to the west side of York Road and began to build a new bank. The Hatboro Bank acquired his site, erected its own bank, and hired Ball as the first cashier. In 1876, Ball absconded with $23,000 of the bank's and depositors' money. After being caught and tried, Ball made restitution; after a few more minor scrapes, he was still considered a respected member of the community He became secretary and subsequently held an interest in an electric light company. In December 1955, the bank merged with the Philadelphia National Bank and, in 1998, it became the First Union Bank.

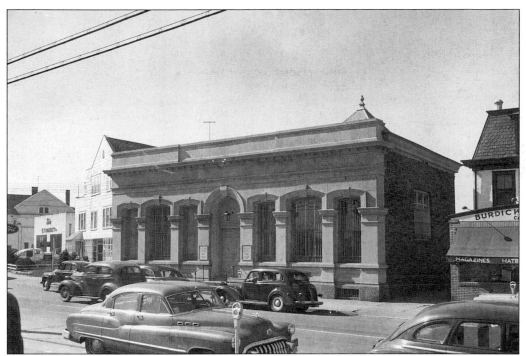

THE ORIGINAL BANK. This photograph shows the original Hatboro National Bank, with the keystone over the center port. The Traction Company building is on the angle directly to the south of the bank. Burdick's News Agency is directly to the right . On the other side of the Traction Company building is the Ruminate Ford Agency. Below that is the Schaeffer farmhouse, which was built c. 1850.

OLD YORK ROAD. This photograph dating from the 1950s shows automobiles that today might appear at Hatboro's annual antique car show. Notice that the trolley tracks still in the middle of York Road. The trolley left Willow Grove, traveled up to Burdick's News Agency, and then returned to Willow Grove, which was a large connecting terminal at the time.

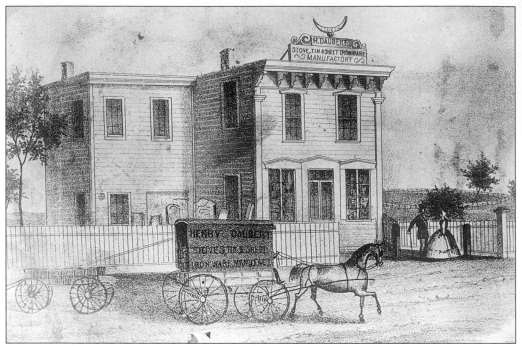

**DAUBERT'S MANUFACTORY.** Henry Daubert's stove, tin, and sheet ironware manufactory was one of Hatboro's early businesses. Pictured in the 1850s, it was located on the east side of York Road below Byberry Road. Very little is known about this early Hatboro firm, and all that is left is the above picture from an early advertisement.

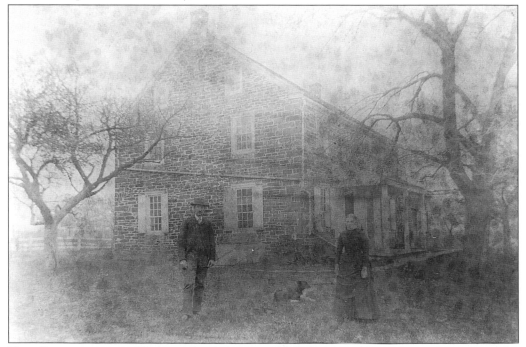

**THE BUTTERWORTH HOUSE.** This house was built before 1760 and was located on the southeast corner of South York and Byberry Roads. This picture was taken in the 1860s.

**SHILES DRUGSTORE.** A three-story wedge-shaped building, Shiles Drugstore is directly at the foot of Byberry Road on the west side of South York Road.

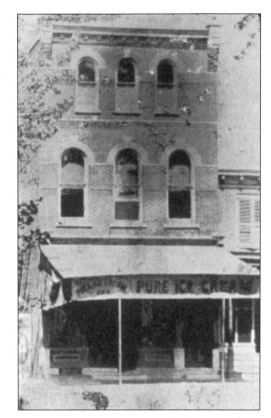

**THE FLOOD OF 1938.** The picture shows the junction of Old York Road and Byberry Road in Hatboro during the flood of 1938. This picture, taken from the roof of the Amoco gas station (now the Sunoco Station), provides a good view of the center of Hatboro, which was considerably afloat.

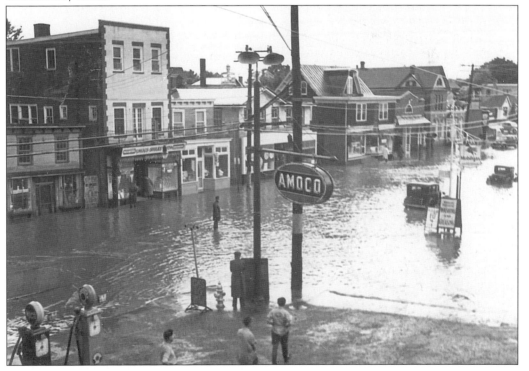

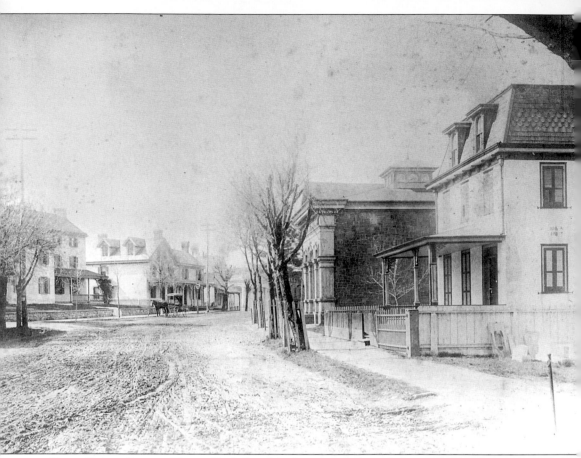

**YORK ROAD SCENE.** This is York Road looking south from Byberry Road. This picture was taken c. 1890 and shows what became Burdick's News Agency. At the time, it was the Marble Carvers, craftsmen of monument and gravestone work, evident from the work that is shown in the side yard. The next building to the south of Burdick's is the Hatboro National Bank, built in 1873. The Joshua Potts House was located on the elbow side of the bend at the top of the York Road hill. It was Joshua Potts's first home, which later became the first home of the Hatboro Library Association. It was built for him in 1743 by his father. The next building is the present Hatboro Federal Savings and Loan building. When this picture was taken, York Road was still a dirt road, and Hatboro still had a rural atmosphere.

# Two

# SOUTH YORK ROAD

## BYBERRY ROAD TO
## MORELAND AVENUE

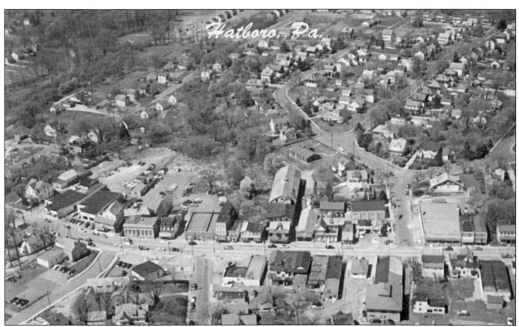

**AN AERIAL VIEW OF HATBORO.** This view of the center of Hatboro was taken in 1951, looking south. It shows Williams Lane coming down to York Road on the right, and Byberry Road coming up to York Road in the left center. Some of the buildings pictured elsewhere in this book can be seen here.

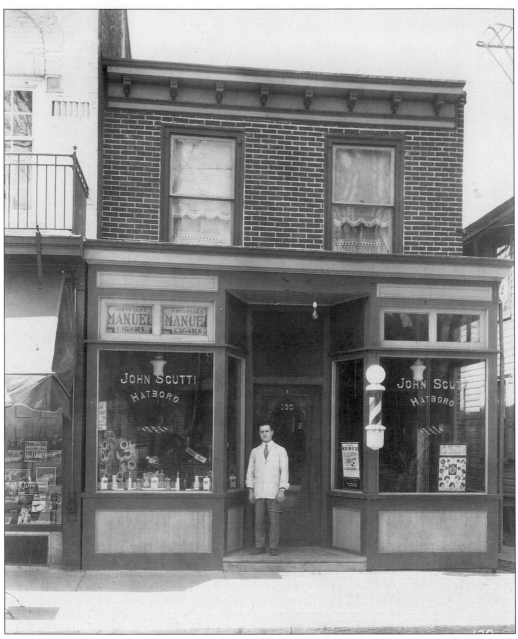

**JOHN SCUTTI BARBERSHOP.** This shop stood on South York Road at the foot of Byberry Road. This photograph, taken *c.* 1929, shows John Scutti standing in front his typical old-time barbershop. Scutti sold good quality cigars, as well as providing haircuts. Look for the cigar advertisement in the upper window of the shop.

**THE BUTTERWORTH HOUSE.** This hip-roof stone house was located on the northeast corner of Byberry and York Roads. The site was later occupied by a dry cleaning establishment. In this picture is a hitching post along Byberry Road. Behind the building, to its extreme right, is the home of John Liedy, where Victor Herbert was a guest while working on his two most famous operettas, "Babes in Toyland" and "The Red Mill."

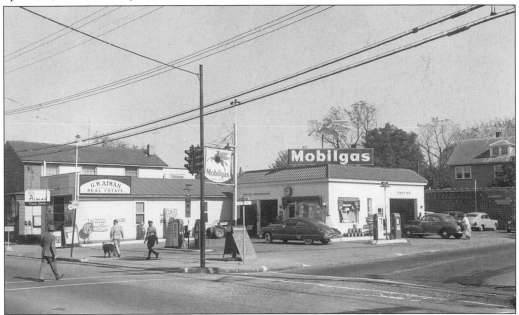

**YORK ROAD CORNER.** This picture was taken in 1952, looking at the northeast corner of Byberry and York Roads. The Mobil gas station on the corner later became Big John's Texaco Station. To the right on Byberry Road is Beifus's Shoe Repair. Next to the Mobil Station on York Road is the G.W. Aiman Real Estate office.

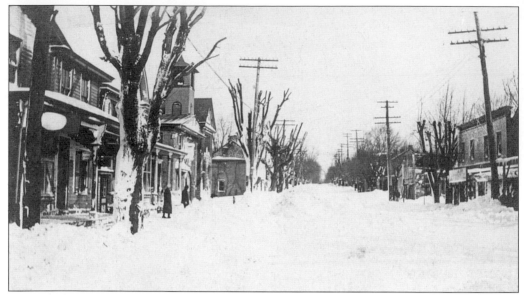

**THE BLIZZARD OF 1898.** This photograph was taken in 1898, looking north. It shows Old York Road from the junction of Byberry Road. At that time, snowplows were not used. Instead, a large roller was pulled by a team of horses to pack the snow for sleighs.

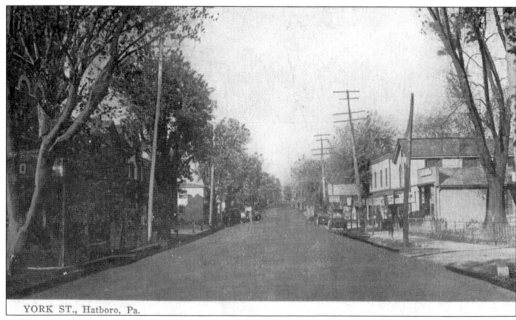

YORK ST., Hatboro, Pa.

**A HATBORO STREET SCENE.** This view of York Road was taken sometime between 1905 and 1910, looking north from Byberry Road. On the right, the east side, is the Vandegrift General Store, which was later divided into two merchandising shops. Farther up, at the corner of Moreland Avenue and York Road, is the Railroad Hotel. Coming down on the west side, there is Shiles Drug Store, the bakery, the Kerns Flower Shop, and Benjamin Williams's farmhouse.

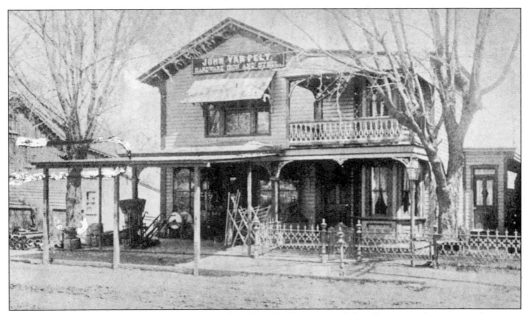

**JOHN VAN PELT'S GENERAL STORE.** John Van Pelt's general hardware and mercantile store was located on South York Road near Byberry Road in the late 1800s. Mr. Van Pelt, the Burgess of Hatboro, also resided in this building.

**HATBORO STORE.** Taken in the 1950s, this picture shows the building that once housed the *Public Spirit* newspaper, a butcher shop, a realty office, and lastly, Jack's Men's Shop. It was later torn down and replaced by a new Jack's Men's Shop. It was on South York Road, north of Byberry. Rube Chatburn's Mobil station was on the south side of this shop.

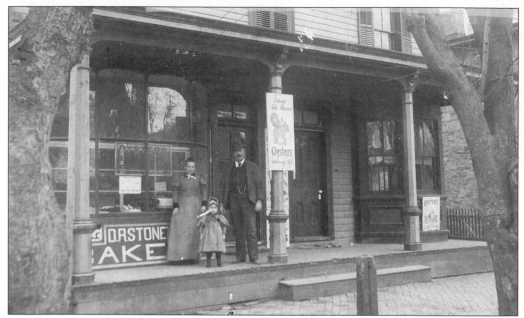

**D.R. Stone's General Store.** This is a late-1800s photograph of Dan Stone's General Store, which operated as such for several generations. Begun by Stone's grandfather, it later became the Hatboro Bakery operated by S.S. Gehman. Once believed to have been located at the corner of Moreland Avenue and York Road, later becoming the Jamison and Carroll Appliance Store, it actually was and still is located just north of the old Enterprise Fire Company building. Posing in front of the store are Stone, his wife, and daughter, Mary.

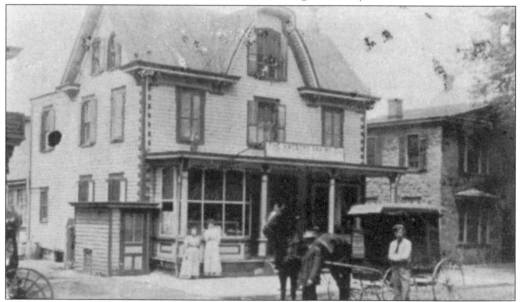

**The Hatboro Baking Company.** This delivery wagon is ready to make a delivery of fresh baked products by the S. S. Gehman Hatboro Baking Company. The picture was taken in the 1890s. In later years this was to become the first Suntheimer's Bakery, which later moved to 120 South York Road. Its telephone number was Hatboro 1663. The building is still in use as Hatboro Jewelers and the East Coast Volleyball Store.

YORK ROAD SCENE. This photograph was taken looking south on South York Road, north of Byberry Road. On the right, the west side, is the Hatboro Fire Company and Town Hall, where the clock was then located. Today, the clock is located in front of the Miller-Cornell Insurance Company. Also pictured are a bakery, Hungerford's paper store, Scutti's Barbershop, and Stiles Drugstore. On the left, the east side, is the office of Garner's Lumberyard and Mason's Buick, with the gas pumps in front of the building. Also visible is the soon-to-be-dismantled Jones and Paxton Lumberyard office, which stood immediately next to Garner's.

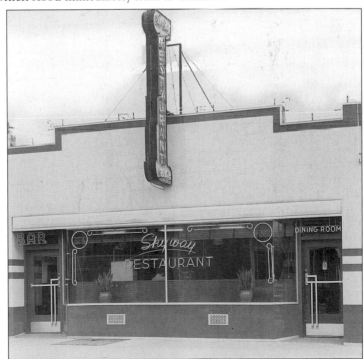

THE SKYWAY RESTAURANT. This is the Skyway Restaurant, located on the east side of York Road at the foot of Williams Lane. It is still operating today as Tooey's Tavern.

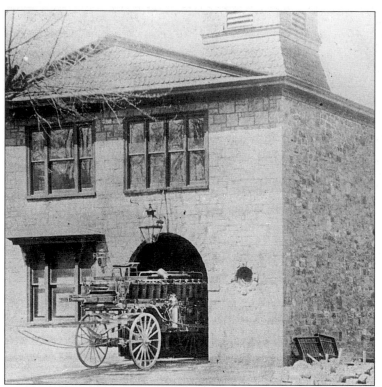

**THE FIRST TOWN HALL.** This 1891 photograph shows Hatboro's first town hall the first home of the Enterprise Fire Company of Hatboro. The firehouse was on the ground floor, as was the jail. The upper floor served as meeting rooms. Note the tower for hanging and drying fire hoses. Also note Hatboro's first fire truck, a horse-drawn pumper and hose wagon. Building material left over from construction is visible at the lower right. The building was completed in July 1891.

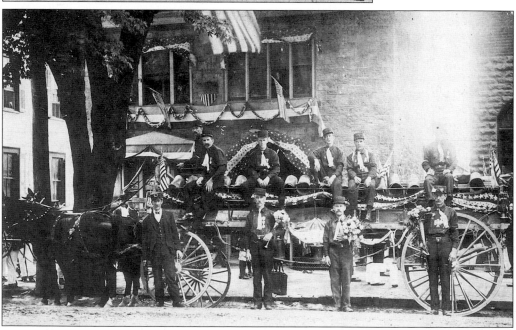

**THE ENTERPRISE FIRE COMPANY.** This picture of the Hatboro Enterprise Fire Company getting ready for a parade was taken in the early 1900s. Shown are, from left to right, the following: (top) George Katz, Fred McVaugh, Alfred Downs, Harry Decksen, Edwin Shinn, and William Craven; (bottom) Howard Winner, George Duncan, E.J. Amber, Howard Clark, and D.A. Clark.

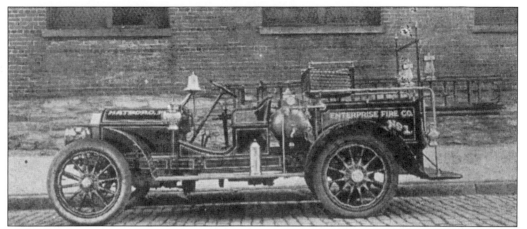

**CHEMICAL FIRE TRUCK.** The Enterprise Fire Company was founded in May of 1890. Dues were $1 to join and 25 cents per year. This Walter Chemical Truck arrived in 1911 and was the first motortruck purchased. It was replaced in 1914. Much fund-raising had to be done to pay for these vehicles.

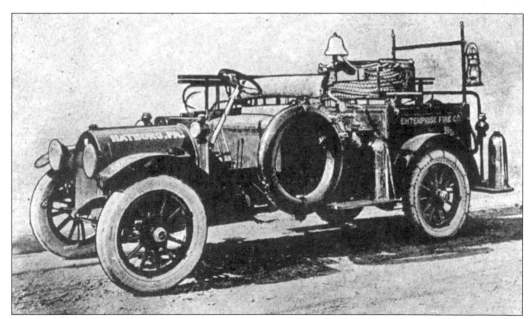

**BUICK FIRE ENGINE.** This Buick fire engine was purchased in 1914 from S.W. Mason, the Hatboro Buick Agency, at a cost of $1,205. It was replaced in 1919 with a Hale pumper on a Simplex chassis at a cost of $2,300. Fire companies have always had to update their equipment to best serve their communities.

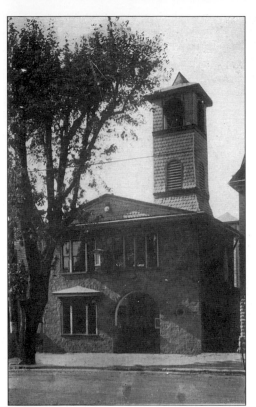

**TOWN HALL.** In August, 1890, 34 volunteers acquired a horse-drawn pumper truck and organized the Enterprise Fire Co. They made immediate plans to build a firehouse on South York Road, which also housed the town jail. In 1899, the jail was moved so that the company could build a hose tower. Later, the town hall and the police station occupied the building. In 1955, they moved to their own new building on Montgomery Avenue, near the railroad. Then, the fire company built new larger quarters and moved to its present location on Byberry Road. The borough offices moved into renovated quarters in the Loller Academy. This original building is where the Kiwanis Club offers oranges and grapefruit before Thanksgiving and Christmas each year. It is currently undergoing renovation for a new use.

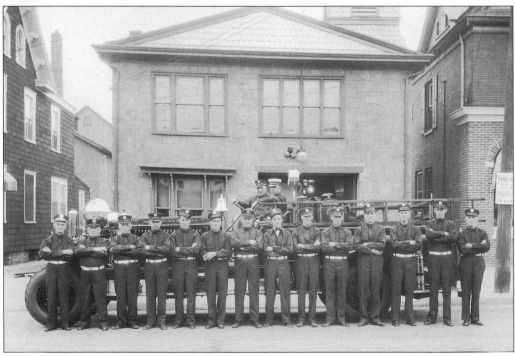

**THE FIRE DEPARTMENT.** Members of the Enterprise Fire Company of Hatboro pose with their brand-new pumper truck in the 1920s.

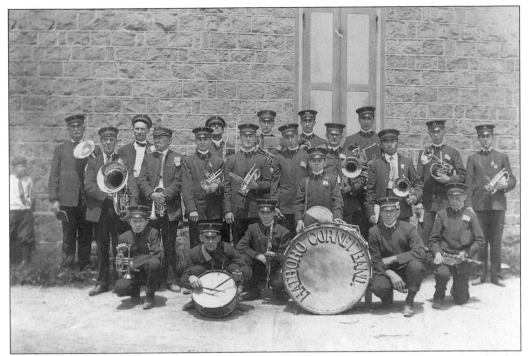

**THE HATBORO CORONET BAND.** In every small town, there seems to be a town band. This band was active from *c.* 1870 to 1920. There was a great deal of pride in the town bands, which often played at adjoining towns' events and parades.

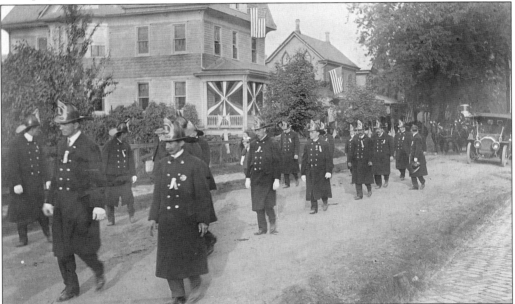

**A HATBORO PARADE.** Members of the Hatboro Enterprise Fire Company parade down York Street in the 1890s. Hatboro, as the only town in existence then, was the hub for shopping, taverns, hotels, and public transportation. The idea of parades started after the Civil War when the Grand Army of the Republic (GAR) veterans gathered on Memorial Day and marched on York Street to remember and pay homage to their comrades.

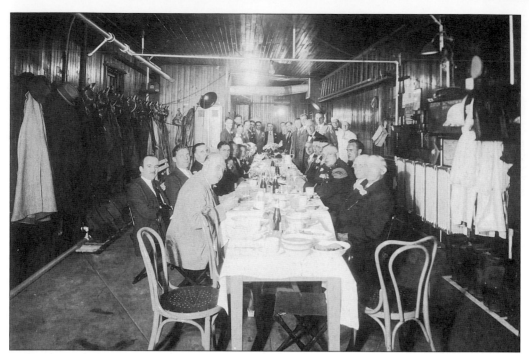

**A FIREMEN'S DINNER.** This Enterprise Fire Company dinner was given by Dr. John B. Carroll, far right, in the 1930s. The police officer in the center is Chief Kramer, who in 1935 was killed in a traffic accident. The man on the far left is real estate agent Warren Cornell.

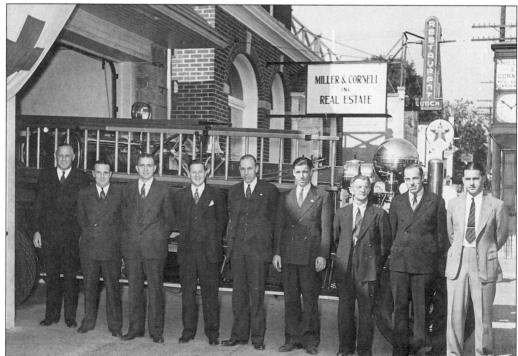

**THE FIRE COMPANY DIRECTORS.** This photograph of the directors of the Enterprise Fire Company is believed to have been taken in the early 1940s.

50

**THE OFFICE OF MILLER AND CORNELL.** This was the first office of Miller and Cornell, located on the site of Ben Williams's farmhouse, now Williams Lane and York Road. At this time in the 1920s, the Williams farm was just undergoing redevelopment for businesses and homes.

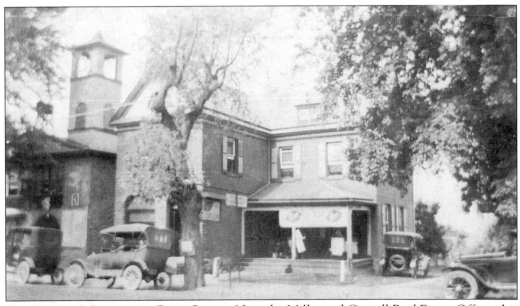

**THE GENERAL STORE AND POST OFFICE.** Now the Miller and Cornell Real Estate Office, this building was at one time the Duffy, McTighe, and McEllone office. Originally, it was used as a general store and post office, as shown here.

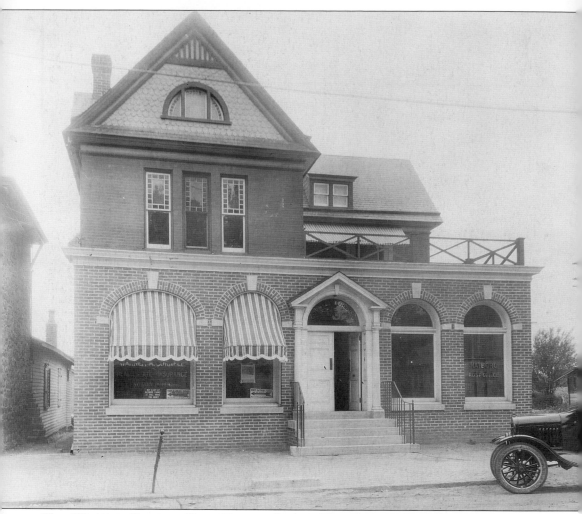

**THE WARREN CORNELL REAL ESTATE OFFICE.** This photograph of the Cornell office on South York Road was taken in the 1920s, shortly after a new wing was added to the building. Later, Cornell and Miller merged and moved both offices into this building. A clock was placed out front on the sidewalk, and its workings were controlled from inside the office.

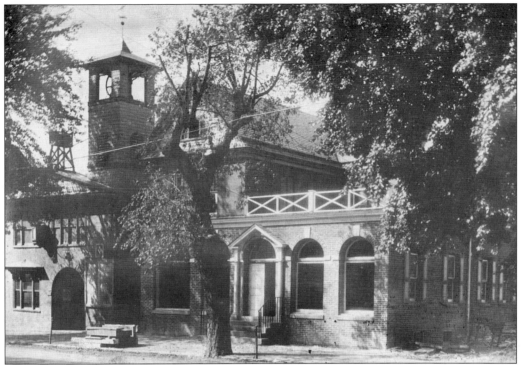

**THE MILLER AND CORNELL REAL ESTATE BUILDING.** This building is on the west side of York Road below Williams Lane. Next to this building, heading south, is the old Enterprise Fire Company and town hall building.

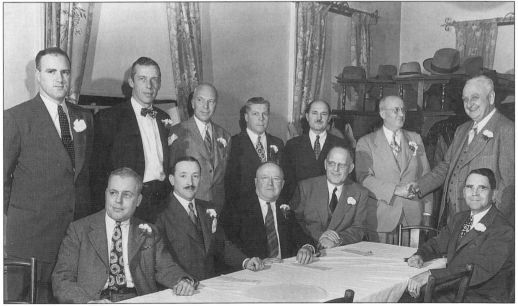

**THE EASTERN MONTGOMERY REAL ESTATE BOARD.** Shown are, from left to right, the following: (front row) W. Clyde Cowley, Tom Montague, Howard J. Dager, William Roberts, and Alfred Trank; (back row) Kindall S. Renniger, John C. Miller, John P. Henry, Walter J. Gallagher, J. Cegielkowski, William Cornell, and H. Renney.

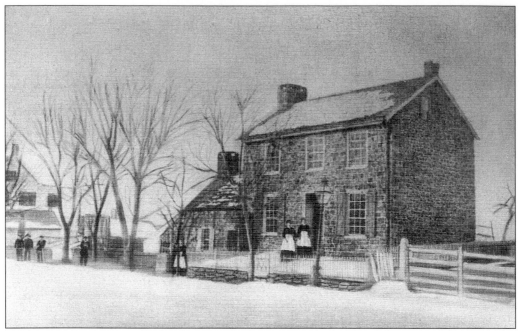

**THE READING HOME.** This home of Dr. Reading is on the corner of York Road and Williams Lane. It later became the Kerns Flower Shop.

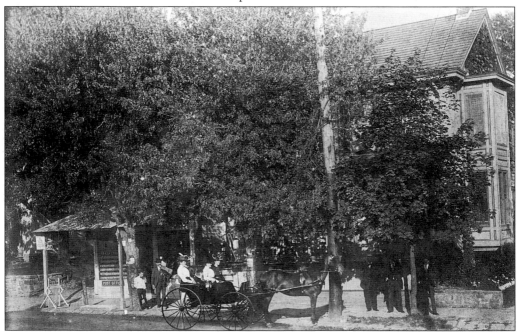

**THE KERNS FLOWER SHOP.** This shop was located on the west side of York Road at the corner of what is now Williams Lane. At the time of this picture, the shop was serving the town of Hatboro as a post office as well. The post office moved from place to place as the postmasters changed, which normally happened when the political party in power changed, as the job of postmaster was a political appointment at the time. Thomas Reading was the first owner of this home. His daughter, Alice, inherited the property. She was the wife of James P. Kerns.

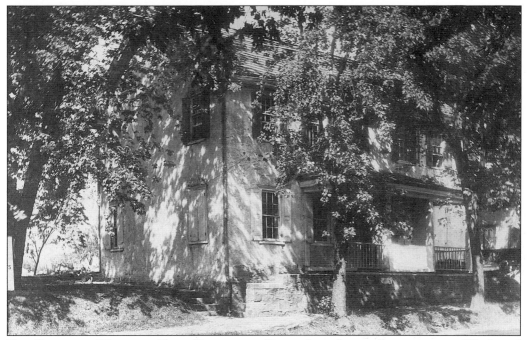

**THE BENJAMIN WILLIAMS FARM RESIDENCE.** Situated on the northwest corner of York and Williams Lane, this site was later the location of the F.W. Woolworth Company. The Yankee Clipper diner was on this corner in the 1940s and 1950s, and it is currently the site of the LaFontana Restaurant.

**A HATBORO BARN.** How would you like to see a barn like this in the middle of Hatboro? This photo was taken in 1897 by Walter L. Reading. In the picture, from left to right, are Lucy Williams, Lilly Williams, and Benjamin Williams, standing by Benjamin Williams's barn on Williams Lane. This picture clearly shows what the mode of transportation was then.

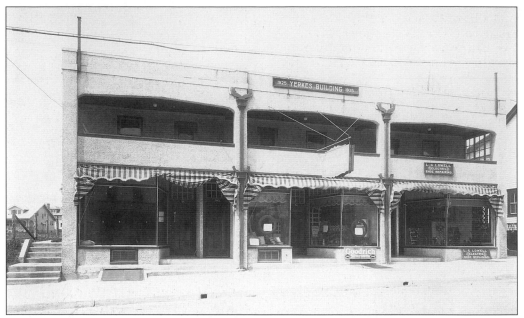

**THE YERKES BUILDING.** Built in the 1920s, this building contained three stores, an open porch area above, and apartments in the rear. This was the former home of Len's Shoe Box. To the left, out of sight, was the Yankee Clipper Diner.

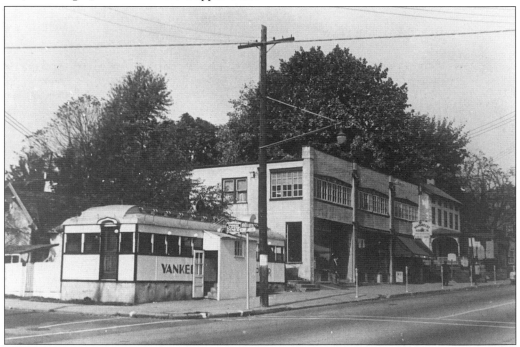

**THE YANKEE CLIPPER DINER.** Back in the 1940s, the Yankee Clipper Diner was a popular spot. Townspeople and merchants went there often for a break, for a chat with friends, or for breakfast, lunch, or dinner. The diner was moved to York Road in Willow Grove in the mid-1950s, and the F.W. Woolworth store came to town in its place. There are still many people who remember having coffee and doughnuts at the diner.

**A DOCTOR'S OFFICE.** This 1910 picture is of an early doctor's office in Hatboro. The building stood on the east side of York Road between Moreland Avenue and Byberry Road. It was built around the time of the Civil War. Notice the plaque that the doctor had on his front porch, which was also his waiting room; patients sat on the benches on the front porch while waiting for their appointment.

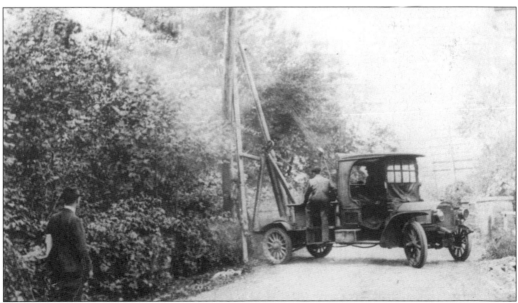

**THE TELEPHONE COMPANY AT WORK.** This is a rare picture of a telephone crew setting a pole in Hatboro in the early 1920s. Hatboro had the service of two telephone companies at one time, Bell and Keystone. It is not known which company is shown in this photograph. Each company had its own crew, and there was keen competition between the two.

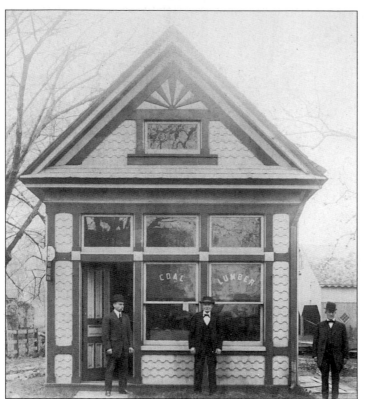

**THE JONES AND PAXTON LUMBERYARD AND COAL OFFICE.** This Victorian-period structure is the building that preceded the Garner Lumberyard. It stood exactly where the Garner office stood, at the foot of Williams Lane, on the east side of York Road. The lumberyard was directly behind this building. It was one room deep and one-and-a-half stories high. The man in the center of this photograph is Thomas Paxton.

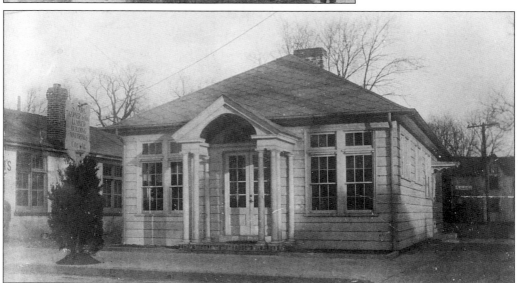

**THE S. CARL GARNER LUMBERYARD.** This is the office of Garner's Lumberyard, which also sold building materials. It stood on the east side of South York Road, north of Byberry Road, approximately where Gamburgs's furniture store is now. The coal and lumberyard office was toward the rear of the building. The coal and lumberyard ran from York Road on the west to Depot Street (now Penn Street) on the east. Rail cars with coal and wood were routed into the yard from the main line that ran along Depot Street. The rails crossing Penn Street are still visible in front of the railroad depot.

**STEPHAN MASON'S BUICK AGENCY.** This early Buick agency was located on South York Road, north of Byberry Road, in 1925 — 1930. It was next to the S. Carl Garner Lumberyard office and later became the Gamburg Furniture Store.

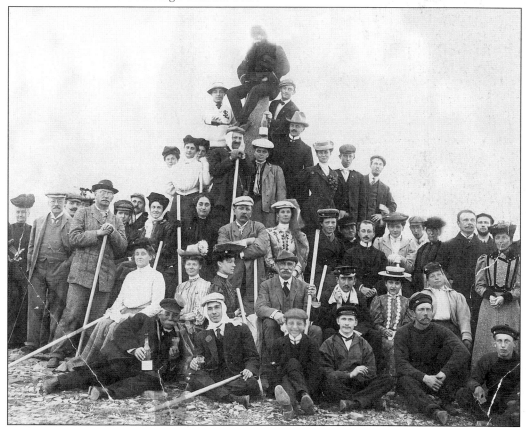

**SOME HIKERS.** This picture was found in L.B. McIlhatten's old lumberyard. It shows an unidentified group of hikers posing with their walking sticks in the late 1800s. Notice the fellow near the top who is pouring the contents of his bottle on the hiker below him.

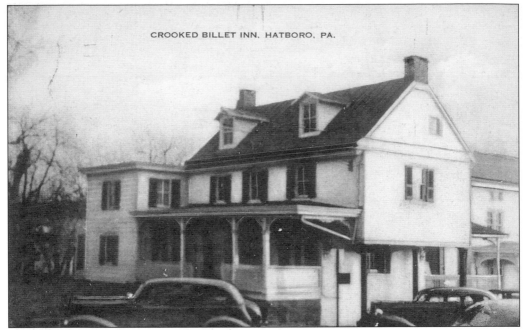

CROOKED BILLET INN, HATBORO, PA.

**THE CROOKED BILLET INN.** Perhaps one of the most famous spots in all of Hatboro was the Crooked Billet Inn. Built in 1734 above a Pennypack feeder stream by one of Hatboro's founders, John Dawson, this building first served as Dawson's family home. It stood on the east side of York Road between Moreland Avenue and Byberry Road. It was best known after 1745, however, when it served as the stagecoach stop and was operated as an inn by Dawson and his jolly innkeeper Nathaniel Loufbourrow. The inn was a common and popular gathering place for locals to learn the latest news, as well as to enjoy food and drink. It has been called the Crooked Billet Tavern, the Upper Tavern, and the Crooked Billet Inn. Because of the inn's great popularity, the town was often called Crooked Billet. Gen. George Washington once referred to the town as "the Billet" in a letter he wrote from here. Washington, among countless other notables and common citizens, enjoyed food and drink here. Later, this building also served as the home of the Union Library. This landmark underwent many changes over the years. Notably, it originally was flush to the ground and did not have the covered walkway. In spite of its architectural and historical significance, the building no longer exists. In 1954, it was purchased, torn down, and replaced by newer structures. There is a plaque on the present building front noting the site's past. In the late 1990s, the buildings on the site were occupied by Joys and Toys Collectibles, Paul's Barber Shop, and Fratone's Jewelry Store.

**THE J. WATSON HOME.** This was J. Watson's home on North York Road. It was located between the Odd Fellows Hall and the Crooked Billet Inn. The Jules Pilch Men's Store now occupies the site.

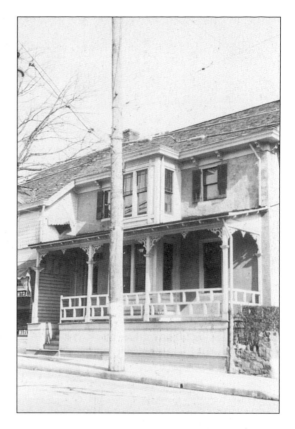

**MARY EISENHART HOME.** This picture of the house taken in the 1920s or early 1930s was located next to the Crooked Billet Inn, seen to the left of the house. At the time, it was owned by Mr. and Mrs. Beaman who are pictured standing in the front yard. This site is now part of Gamburg's Furniture Store, "Serving our community for four generations."

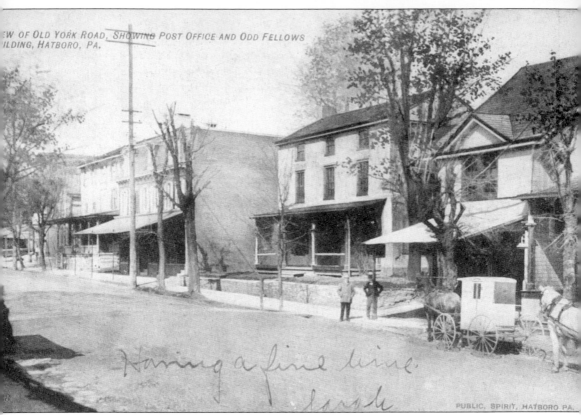

*Having a fine time.*

PUBLIC, SPIRIT, HATBORO PA.

**OLD YORK ROAD.** This postcard *c.* 1900 shows the post office and the Odd Fellows building. At the time, the post office shared a building, which later became Miller and Cornell Realtors. The telephone switchboard was also there for a time. On December 10, 1810, the U.S. post office was established in Hatboro, or Hatborough, as it was then called, and the earliest recorded receipts of $29.18 were for the year 1827. The post office, usually in the home of the postmaster, was also at various times in the Hatboro National Bank building, a building on Byberry Road, the present Colonial Realty, and the Railroad Hotel. On November 19, 1960, it moved into its own new building.

**THE HATBORO POST OFFICE AND TELEPHONE EXCHANGE.** This building stood on the east side of York Road between Williams Lane and Moreland Avenue. It was the Bell Telephone office. The Keystone Telephone and Telegraph exchange had an office on the west side of York Road, almost across the street from this building. In Hatboro in 1908, all of Bell's customers were on the east side of York Road and all of Keystone's customers were on the west side of York Road. Anyone wishing to make a call to the east side had to have had a Bell telephone, and those wanting to call the west side had a Keystone telephone. Businesses were required in many cases to hold two telephones, one Bell and one Keystone, as did any residents who wanted to be able to call both side of York Road.

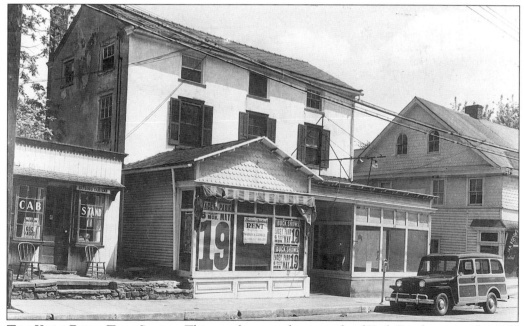

**THE YORK ROAD TAXI STAND.** This stand was on the east side of York Road, next to the Odd Fellows Hall (now Jules Pilch). This picture clearly shows the changes in style and use of buildings over time.

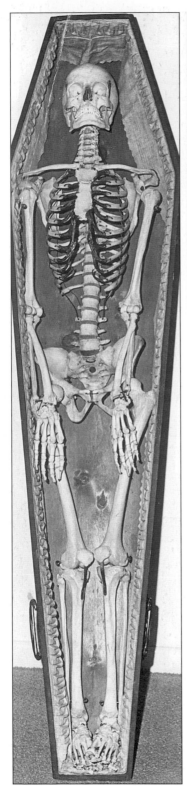

**THE ODD FELLOWS LODGE.** Built in 1851, this three-story Federal-style building with Victorian modifications was located on the east side of York Road across from what became the CVS Pharmacy. The building was torn down in 1967 and was later occupied by the Jules Pilch Men's Store.

**MATILDA.** These remains of some departed soul were used in ceremonies of the Odd Fellows Lodge in Hatboro. When the Odd Fellows building was torn down in the 1960s, the skeleton was sold, complete with its solid walnut casket, to Mrs. James Davidson of Hatboro. When Mrs. Davidson saw the skeleton, her first words were, "There's Matilda!" With this remark, she named the remains, and the name stuck.

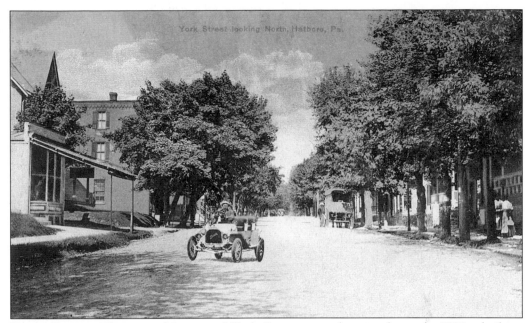

**YORK STREET.** This peaceful view of York Street was taken in the early 1900s, looking north toward Moreland Avenue. Note the horse and wagon coexisting with the automobile. The building on the left with shuttered windows, behind the tree, is the current Dimitri's Pizza Shop.

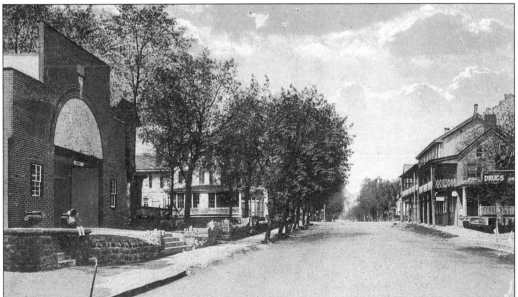

**A TOLL ROAD.** North from here, York Street was still a toll road when this picture was taken in 1915. The toll for a one-horse carriage was 2¢, and a two-horse carriage could pass for 3¢. The street had been widened in *c.* 1884, sacrificing the trees and porches. This occurred with much protest by the Hatboro citizenry. The Hatboro Auditorium shown on the left was built by Ernest and Penrose Robinson for stage performances. Those performances cost about 35¢, and silent movies, with stars such as John (Jack) Gilbert, cost 25¢. The large building partially obscured on the right is the Railroad Hotel.

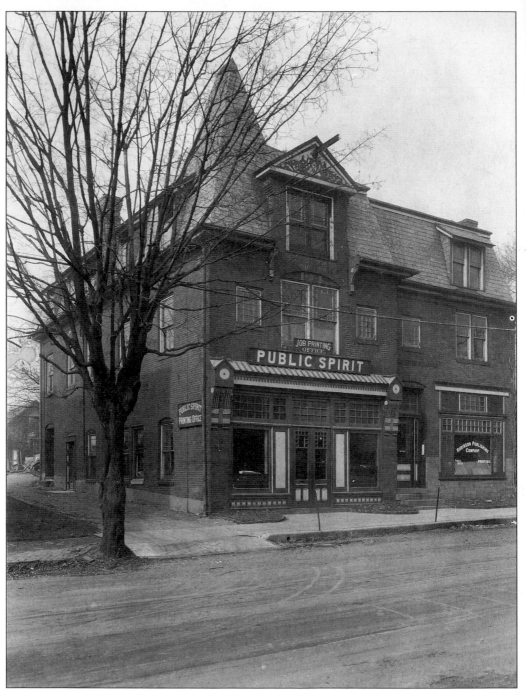

**THE PUBLIC SPIRIT.** This 1920 picture of the Public Spirit building, on the west side of York Road south of Moreland Avenue, was home to Mr. and Mrs. Penrose Robinson. They used the north side of the building as their residence, while publishing the *Public Spirit* newspaper from the south side. The building was later torn down and rebuilt partly for Berlin's Five and Ten Cent Store, which later became the CVS Pharmacy.

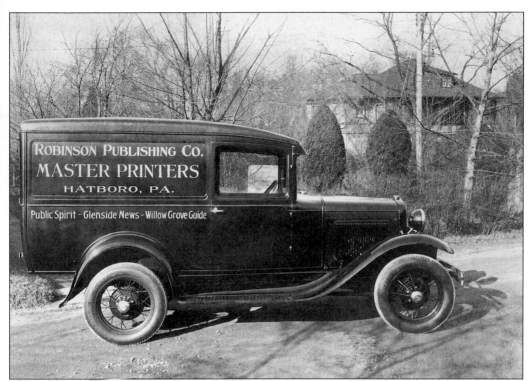

**THE ROBINSON PUBLISHING COMPANY DELIVERY TRUCK.** This was the first truck the Robinson Publishing Company owned. This firm published not only the *Public Spirit* newspaper but also tracts, small books, and pamphlets.

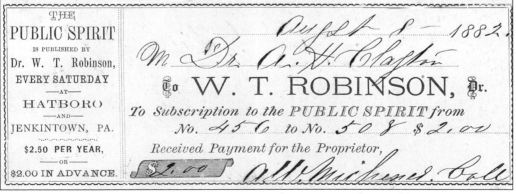

**PUBLIC SPIRIT SUBSCRIPTION.** In 1882, a year's subscription to this weekly newspaper cost a mere $2 paid in advance, or $2.50 regular price—quite a bargain, considering the cost of just one Sunday newspaper today.

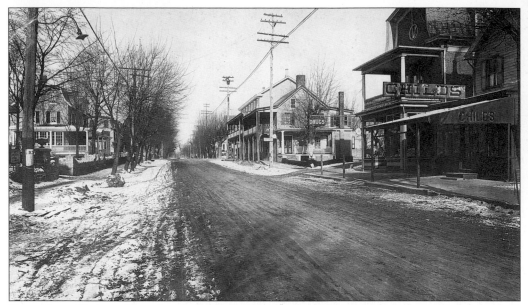

**YORK ROAD SCENE.** This photograph was taken in the early 1920s, looking northeast on York Road. Visible are Childs' General Store and Rothwell's drugstore (later Jamison's Drugstore). After the vacant lot is the Hatboro Railroad House Hotel, which stood on the corner of York Road and Moreland Avenue. Just above that, barely visible, is the Hatboro Baptist Church. York Road was still an unpaved dirt road at that time.

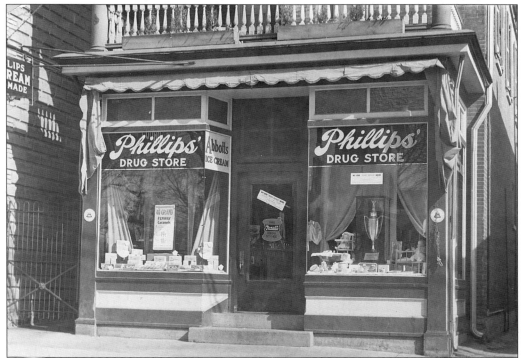

**PHILLIPS' DRUGSTORE.** In the 1940s, this store on North York Road, south of Moreland Avenue, was run by the Phillips family. This picture was taken in the 1960s. It was the former Rothwell's Drugstore.

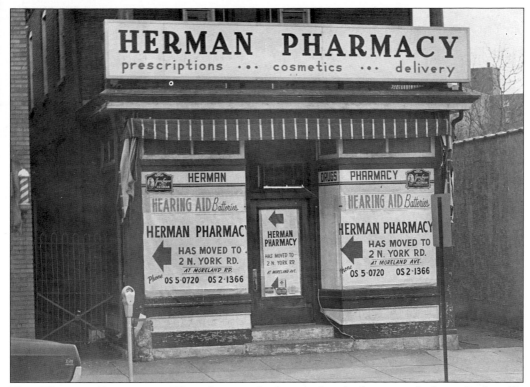

**THE HERMAN PHARMACY.** This photograph shows what had previously been Rothwell's Drugstore and later the Herman Pharmacy, just after Herman moved north to the corner of York Road and Moreland Avenue in the 1960s. In the late 1990s, the second Herman Pharmacy building housed the Hatboro Branch of the Willow Grove Bank.

**JAMISON'S DRUGSTORE.** This picture, taken in 1959, shows the large three-story structure that once stood on the east side of York Road just south of Moreland Avenue. Sam Renzi's barbershop was to the left, and the Jules Pilch Men's Store was to the immediate right. In the 1940s and 1950s, Jamison's Drugstore was a popular soda fountain, frequented by teenagers. In later years, the building was razed and a new structure was built.

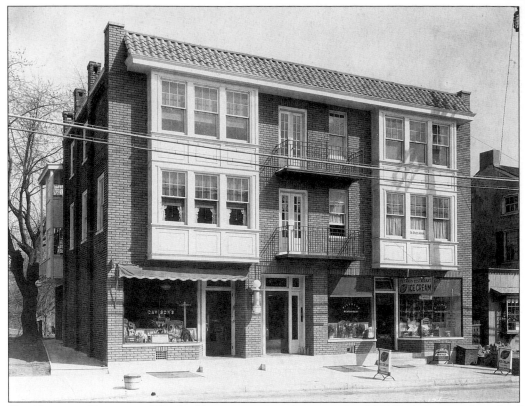

**THE BELCHER BUILDING.** This building situated on the east side of Old York Road and south of Moreland Avenue is just above the present Produce Junction grocery market. The three-story structure was built sometime between 1860 and 1900 and is still standing. The Hatboro taxi stand is on the right.

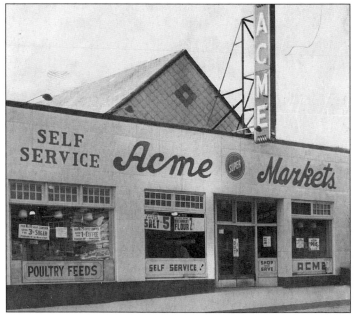

**THE ACME STORE.** Located on the west side of North York Road, south of Moreland Avenue, this was the second Hatboro Movie Theater building. Part of the original building is still visible in the A roofline above the frontage. In later years, the building became the Ben Franklin Five and Ten Cent Store, Berlin's Five and Ten, and the CVS Pharmacy. The Acme moved to a store that later became Big Marty's, on York Road at Lehman Avenue.

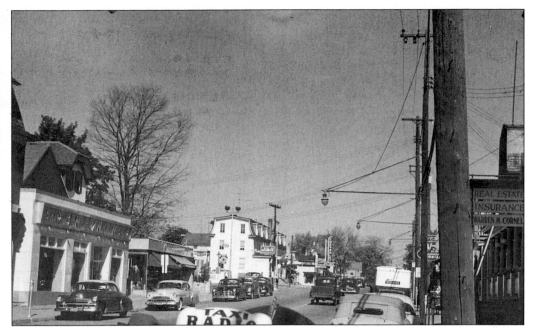

**OLD YORK ROAD.** This view of Old York Road was taken in front of Jamison's Drug Store, looking north. On the left is the Ben Franklin Five and Ten and farther up, the Fisher Building and Smith Chevrolet. A number of pictures of this type were taken in 1952.

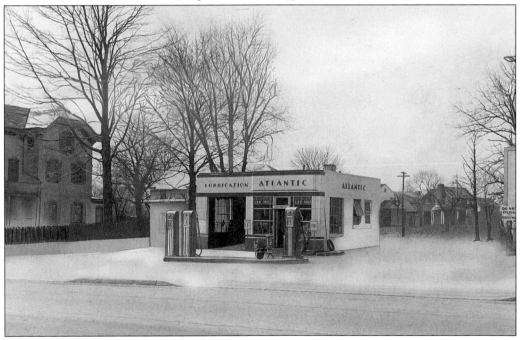

**THE ATLANTIC GASOLINE STATION.** This station, owned by Charles Huber, was one of the earliest gas stations in Hatboro. To the left is a large Victorian home built in the 1880s. In the rear of the gas station, the new Williams Tract was being developed. This picture was taken sometime between the late 1920s and early 1930s. This station was situated on the southwest corner of Moreland and York Roads.

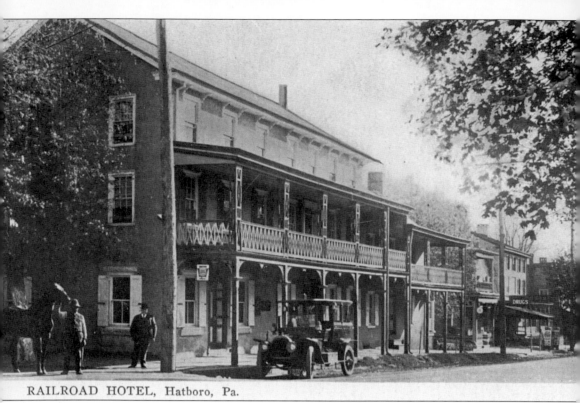

RAILROAD HOTEL, Hatboro, Pa.

**THE RAILROAD HOTEL.** This hotel was also known as Vandergrift's Hotel, the Upper Hotel, or the Upper Tavern until 1872 when the railroad came to town and the construction crew stayed here. It then became known as the Railroad Hotel. This picture was taken in 1914. The hotel was an elegant and popular place, with carriage sheds and stables for horses. Fancy ironwork balconies overhung the sidewalks. In the 1930s, Hatboro again decided to widen the streets and in the process, lost all of the trees and picturesque storefronts. After losing its beautiful balconies, this hotel became a fruit market along a rather drab and barren street.

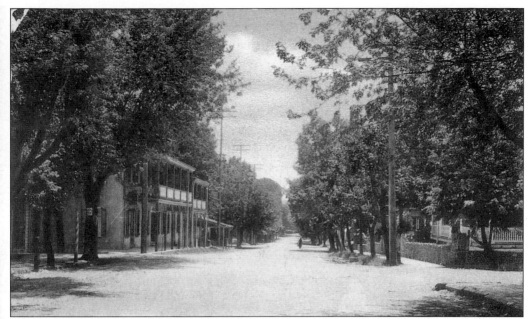

**Stagecoach Stop.** This view was taken in 1909, looking south from Moreland Avenue. The Railroad Hotel, on the left, also served as a stagecoach stop. Many stagecoach travelers stopped to enjoy a meal and a beverage while their drivers rested and arranged for fresh horses. Drivers left their horses here, continued their journey with rested horses, and then picked up their own horses later on the way back. Notice the beautiful trees that bordered both sides of the street, the ample sidewalk, and the storefront porches.

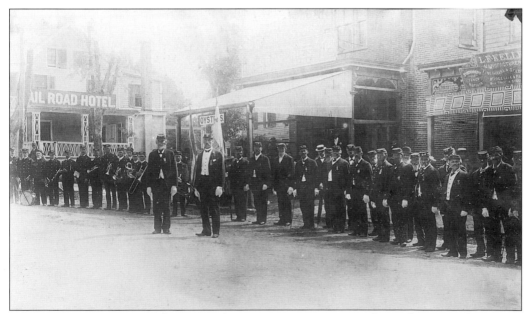

**A Memorial Parade.** Hatboro's Civil War veterans pose on York Road, *c.* 1894, before the annual Fourth of July Grand Army of the Republic memorial parade. This picture was taken just south of Moreland Avenue. The Railroad Hotel is behind the band.

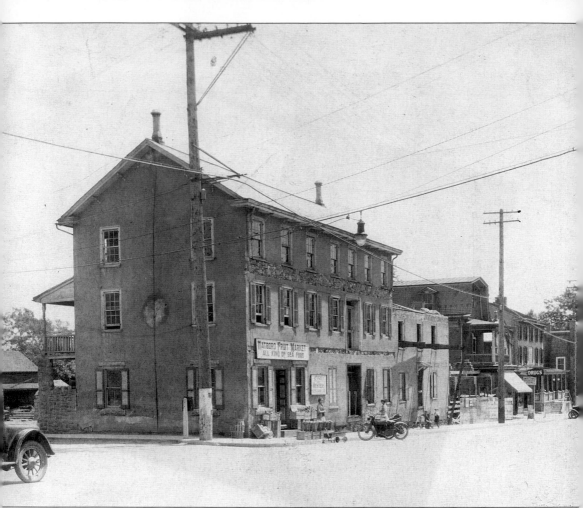

THE FORMER RAILROAD HOTEL. This building was on the southeast corner of Old York Road and Moreland Avenue. Note the fruit market in front, and the motorcycle. This photo was taken right before the building was torn down in the 1920s. Notice how barren the street appears with all the balconies and trees removed. An empty building on the right and Rothwell's Drugstore are also visible.

# *Three*
# NORTH YORK ROAD
## MORELAND AVENUE
## TO THE COUNTY LINE

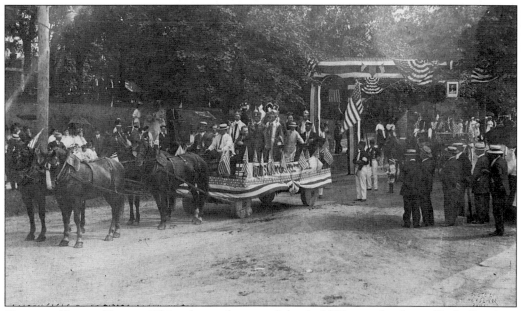

GOLDEN EAGLE FLOAT. This photo shows a July 4, 1908 parade down York Road in commemoration of the 130th anniversary of the Battle of Crooked Billet. May 1, the battle's anniversary date, is usually celebrated in Hatboro for this occasion. For years Hatboro has been known for its many parades up and down York Road.

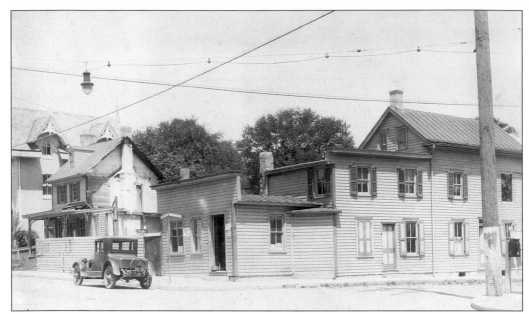

**A YORK ROAD CORNER.** This is a 1920 picture of the northeast corner of York Road and Moreland Avenue. The photograph shows Dr. Reading's home and office at the far left. This is now the site of the post office. The demolition of a brick building (see the image below) is beginning to the right of Dr. Reading's home and office. Rubin Hockman's barbershop, with its open door in the corner building, was soon to succumb.

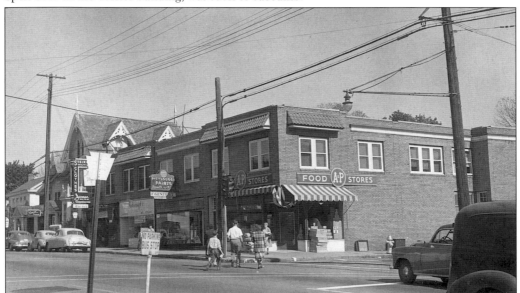

**A LATER SCENE.** This 1952 picture shows the same corner but with all the frame structures to the right of Dr. Reading's home and office replaced by a brick building. The businesses, from left to right, are Stein's Clothing, the Northern Hardware store, and the A&P market. Today, the brick building houses the Bux-Mont Office Supply Company, the YMCA Thrift Store, an antiques store, and the Hatboro branch of the Willow Grove Bank. At the site of Stein's Clothing, the well-known Gamburg's furniture store got its start during the period from 1930 to 1946.

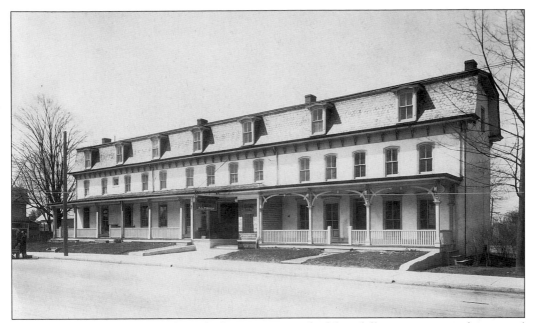

**THE FISHER BLOCK.** The Fisher Block was comprised of five different stores on the ground level, with apartments above. A classic example of a Victorian structure, it stood on the northwest corner of York Road and Moreland Avenue. The second-story apartments appear to be divided into three units. The block was built *c.* 1890 and was torn down in the 1960s to make way for the present Seven-Eleven store.

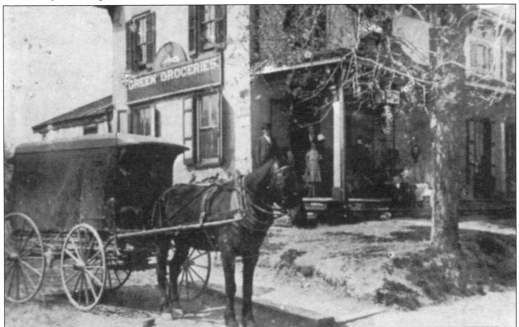

**THE A. HARDING STORE.** The Green Groceries Country Store is pictured here in the 1890s. The horse and buggy was the mode of transportation commonly employed at the time. This is another use of space in the Fisher Block. Over the years, many businesses used the first-floor spaces in this grand, 1800s building.

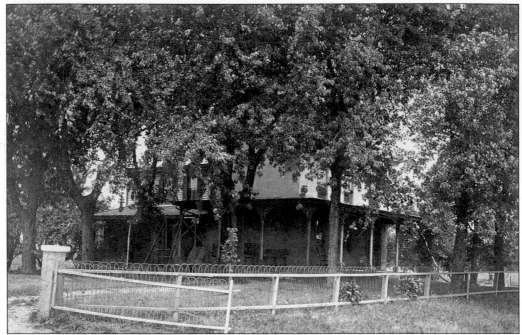

MISS CARRIE YERKES'S HOME. This home, opposite the present post office, was typical of the large colonial Victorian homes located in Hatboro. On York Road, homes like this stood side by side with farmhouses and professional buildings. Many homes had wide porches and large fenced lawns, as does the Yerkes home.

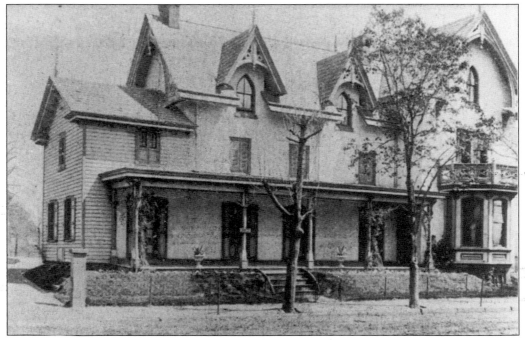

THE ROTHWELL HOUSE. Although built and once lived in by the Rothwell Family, this house was later the home of Dr. Reading. Even later, it served as the post office. The house was designed by H. Trumbauer.

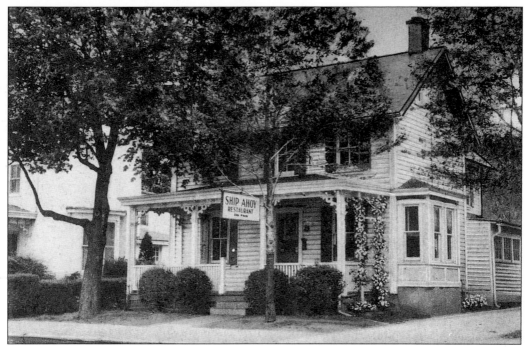

**THE SHIP AHOY RESTAURANT.** A postcard picture of the Ship Ahoy Restaurant shows an open porch before the enclosed porch was added for extra dining. The addition certainly implies that. the food business was doing well.

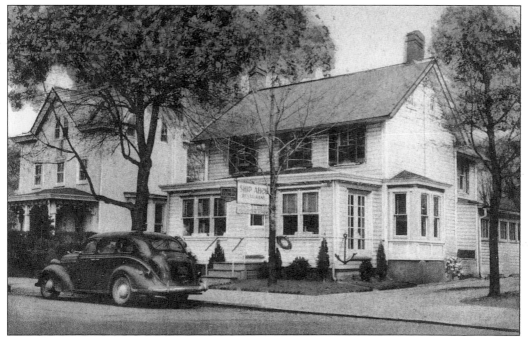

**SEAFOOD TO GO.** Owned and operated by William Belli in the mid and late 1940s, the Ship Ahoy was known for its excellent home cooking and seafood to go. The building, which burned in 1988, stood where the present Leroy's Flowers and Gifts Shop and parking lot are now.

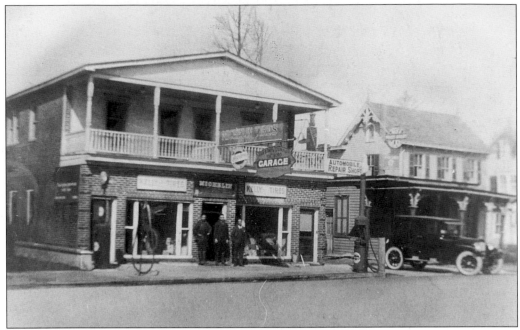

**THE SMITH CHEVROLET GARAGE.** Located on North York Road across from the Hatboro Baptist Church, Smith Chevrolet was built in the 1920s and is still standing. It has since been incorporated into a much larger grouping of buildings. On the immediate right was Dr. J.B. Carroll's first home and his first doctor's office in Hatboro. To the right of that is the Kapusta Taylor Shop.

**DR. J.B. CARROLL'S RESIDENCE.** This is Dr. Carroll's first home. It was located on the west side of North York Road, between Moreland and Montgomery Avenues. Although the home was razed, Smith Chevrolet, Lafferty Chevrolet, O'Neil's Nissan, and then Ernie Brown Plymouth and Dodge occupied newer buildings on this site, which still later were occupied by. the U.S. Navy and Marine Recruiting Office and auto parts and repair businesses.

**DR. JOHN B. CARROLL.** A popular man in town, Dr. Carroll is shown here surrounded by seven well-dressed women. The only other person identified in this photograph is Dr. Carroll's ward, Elinor Morgan, indicated by an X.

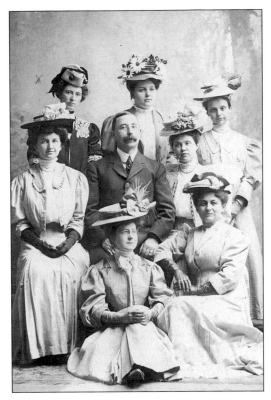

**A CIVIL WAR SOLDIER.** Identified as Charles Danenhower, this soldier was the brother-in-law of Dr. Carroll.

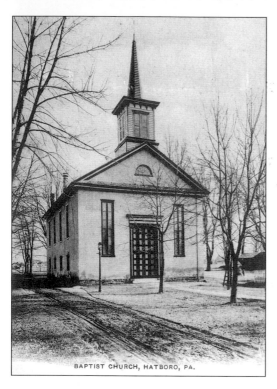

BAPTIST CHURCH, HATBORO, PA.

**THE BAPTIST CHURCH.** The first Sunday school was founded on September 5, 1824. The Baptist Church shown here was organized on September 8, 1835. The church building for this new congregation was not completed until 1840. A newer building was constructed as an addition to the first and still serves the community today. Hannah Yerkes is credited with spearheading the effort to organize both that first Sunday school and the the Baptist church in Hatboro.

**THE BAPTIST PARSONAGE.** This Victorian-era structure was on York Road, just north of the Baptist church. Built *c.* 1860, the building served as a parsonage for many years before it was sold and another parsonage was put into service. This site was later occupied by strip-stores and church childcare facilities.

**A 29-YEAR PASTOR.** Rev. Frank Colby is shown here in his World War I uniform with his two sons, Frank Jr. on the left and Paul on the right. Colby was the minister for 29 years (1906–1922), the longest tenure in the church's history. This image is on a real photo postcard.

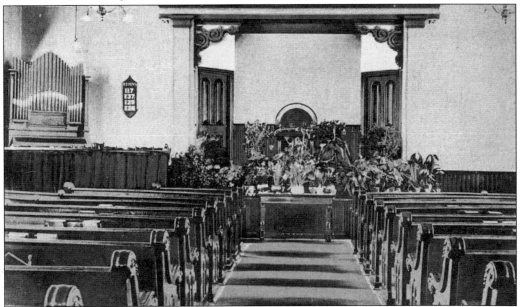

**THE INTERIOR OF THE BAPTIST CHURCH.** The women of Hatboro were largely the driving forces in constituting this church in 1835. The building was erected in 1840 by Joseph P. Yerkes. The first extensive revisions were made in 1857, when the bell tower was added. Through the years many more revisions and additions were made. These additions and revisions were always done with the original style in mind.

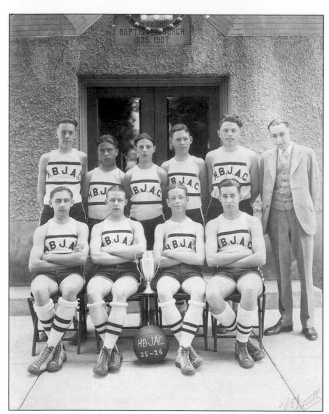

**CHURCH CHAMPIONS.** This is a picture of the Hatboro Baptist Church championship basketball team for the 1925–26 season.

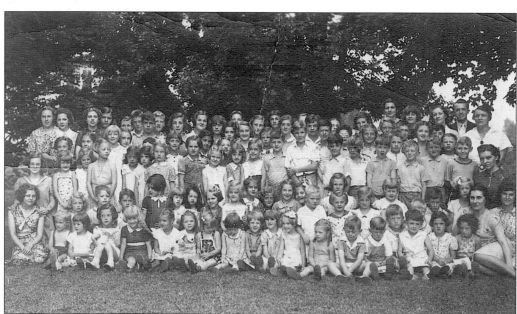

**THE BAPTIST BIBLE SCHOOL.** This picture was taken on the lawn of the Hatboro Baptist Church in the summer of 1938. The pastor, Reverend Lewis, is second from the right in the top row. Others pictured include Frank Parsons, Nancy Ammons, Dorothy Parsons, Nancy Cramer, Eugene Thompson, Nancy Weeks, John Traub, and Jim Traub.

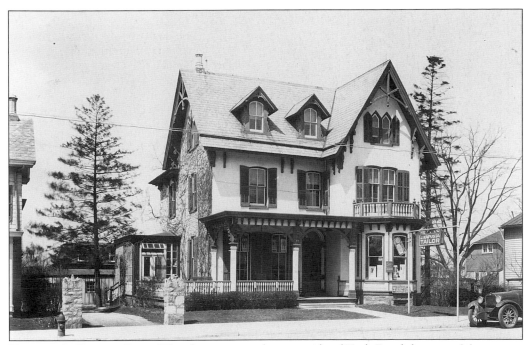

KUPUSTA'S TAILOR SHOP. This shop was on the west side of York Road, between Monument and Montgomery Avenues. It is a good example of early-Victorian architecture in the borough of Hatboro. The building was made of native stone. Kupusta's made men's suits to order. A customer went to the shop, picked out a fabric, and was measured for a suit. After Kapusta's made the suit and made necessary alterations, the customer had a brand-new, custom-made suit. The shop was originally the Thomas Paxson Mansion and after Kupusta's, it became the Hatboro Movie Theater and then Wendy's Old Fashioned Hamburgers.

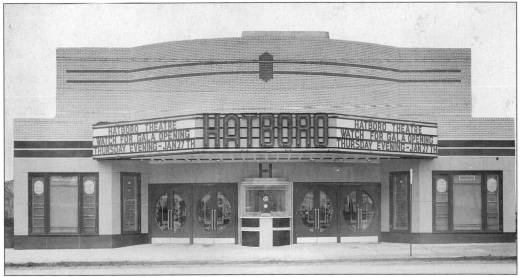

THE HATBORO MOVIE THEATER. This theater opened on January 27, 1938, about the time this picture was taken. The third movie theater in town, the Hatboro was designed in the art-deco style of the late 1920s and early 1930s. In the mid 1980s, this building was razed and the site later became part of Wendy's Old Fashioned Hamburgers.

**DR. EVANS'S MANSION.** This grand Mansion was built by the Honorable Dr. Isaac Newton Evans, who was a prominent physician and congressman. The mansion's shining hour came on September 4, 1889, when Pres. Benjamin Harrison visited Warminster to dedicate a monument to the Reverend William Tennent's Log College. The monument site is 2 miles north of Hatboro on York Road. Harrison dined lavishly while staying as Evans's guest. Through the 1950s, the mansion served as Eddie King's rather plush Hatboro Hotel. It then passed through the hands of numerous restaurateurs, most notably serving as the Rascal's Roost, and had several additions to increase the dining capacity. Currently it houses industrial offices.

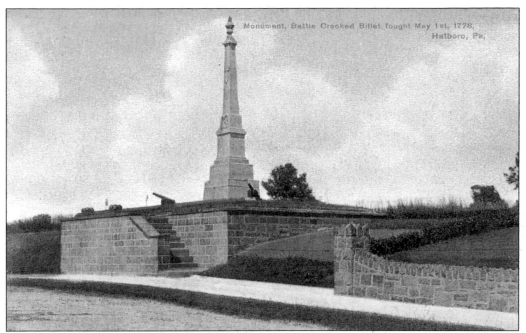

**MONUMENT, BATTLE OF CROOKED BILLET.** This monument was dedicated in 1861 on an island dividing Monument Avenue at York Road, a commanding site at the top of the hill. One hundred and four years later, on May 1, 1965, Dr. James T. Eaton rededicated it at the Crooked Billet Elementary School on the grounds of Lacey's encampment. This monument was dedicated to the 26 killed, 8 wounded, and 58 taken prisoner-of-war, nearly one third of the troops then serving under the 24-year-old Brig. Gen. John Lacey of Buckingham. There is much written and little room herein for the story. The battle, following the Valley Forge encampment, though small, was not insignificant. On April 30, 1778, Maj. John Simcoe's 850 well-trained troops, the 17th Dragoons of American Tories, and the 37th Regiment of Footgaurds set up an ambush on Horsham Road, the figured retreat to Valley Forge. They pushed north in a pincer movement to put an end to the Lacey annoyance of frequent raids on their resources and suppliers. Lacey's ill-trained and poorly equipped troops fell back toward more familiar Bucks County woods, but not before the surprise attack exacted a grievous toll. His scouts Lieutenant Neilson and Ensign Loughlin dallied and then failed to sound an alarm for fear of being shot, so near were the British spotted. Both were court-martialed, but only Neilson was discharged. The former Meadowbrook Elementary School was renamed in honor of the battle on its grounds; it is the only school on a battleground and is distinguished as a declared Pennsylvania historic site.

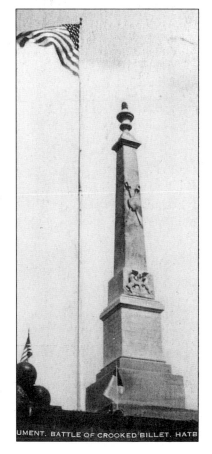

UMENT. BATTLE OF CROOKED BILLET. HATB

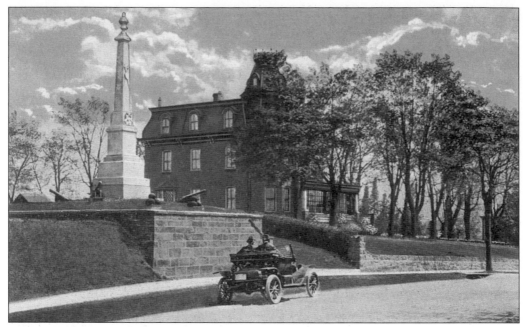

BATTLE MONUMENT. This postcard is of early 1900s vintage. It shows the monument erected to honor the Revolutionary War battle fought in Hatboro and Warminster on May 1, 1778. The home of Dr. Issac Newton Evans was just to the south. Known in later years as the Hatboro Manor, the house later became an office condominium.

THE OLD FRAME SCHOOLHOUSE. This building was the first frame schoolhouse in Hatboro. It was built after the Stone Cabin schoolhouse was built on the corner of Warminster and Byberry Roads in the 1720s. The Old Frame Schoolhouse was located on Old York Road but is no longer standing. Shown in this picture is an octagonal cistern to the left of the building.

**THE FOURTH OF JULY, 1908.** This Sliker real photo postcard shows a Hatboro man on horseback leading the grand parade in Hatboro.

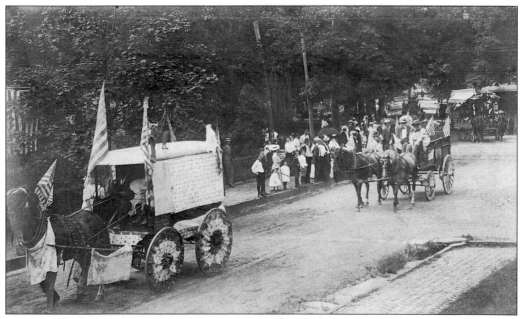

**AN EARLY PARADE.** An early Hatboro Fourth of July parade is shown here on North York Road near the junction of Monument Avenue. Note the decorated carriages and wagons and the orderly crowd watching the parade.

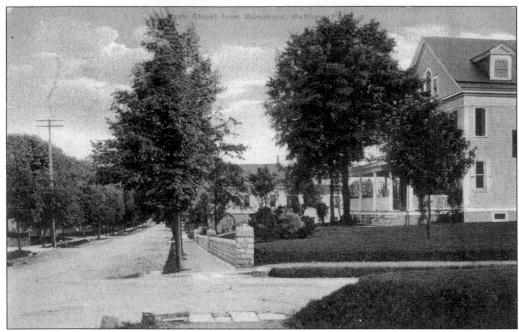

**HALL'S APARTMENT HOUSE.** This apartment house was located on the southwest corner of York Road and Monument Avenue. A large three-story home, it was an apartment house in the 1940s and 1950s. In the mid-1960s, it was torn down and replaced by a McDonald's restaurant. This view from the 1910s was published and printed as a postcard by Mrs. Morgan of Hatboro.

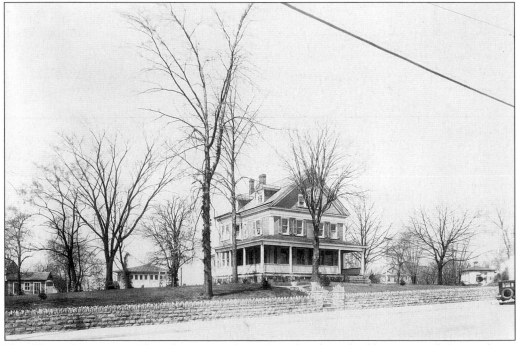

**THE HALL RESIDENCE.** This photo was taken when the above building was still the residence of Charles Hall. It is of the late Victorian period, built sometime between 1870 and 1890. Notice the beautiful stone wall in front of the home.

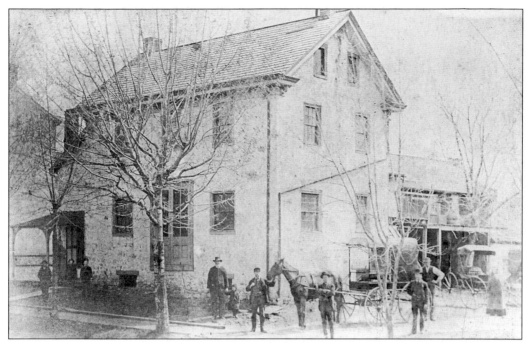

**THE UPPER TAVERN.** This tavern on York Road, also known at one time as the Crooked Billet Inn, was north of Moreland Avenue. This is not the Crooked Billet Inn built by John Dawson but was the tavern used as British headquarters during the Battle of Crooked Billet on May 1, 1778. This photograph was taken in 1870.

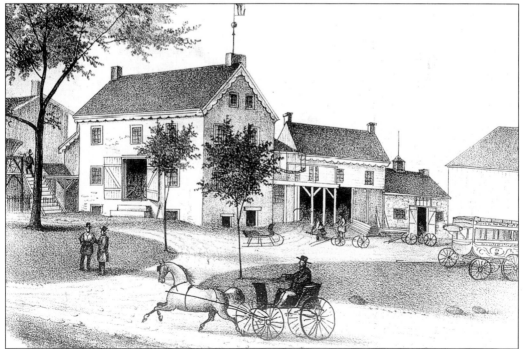

**PEN AND INK SKETCH.** This is an excellent pen and ink sketch made in 1840 of the same inn as above, known then as the Upper Tavern.

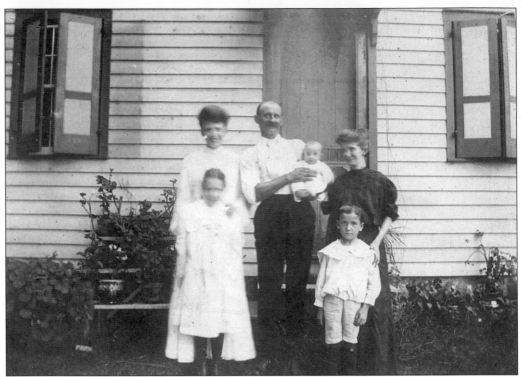

**THE TOLL TAKER AND FAMILY.** William Worthington, the toll taker, stands with members of his family in front of Toll House No. 2 at York and County Line. He was the father of Mae and the father-in-law of Wilmer L. Craven. The Exxon Gas Station later occupied this site.

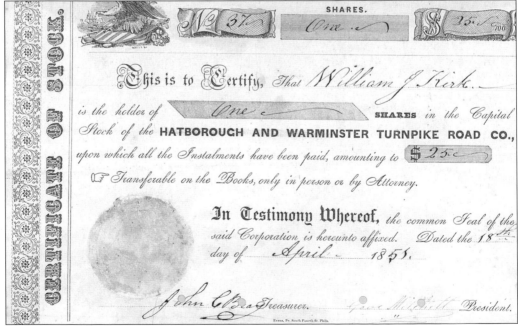

**ONE TURNPIKE SHARE.** This certificate shows how much one share of the Hatborough and Warminster Turnpike Road Company cost in April 1855: $25.

# *Four*
# SECONDARY STREETS OF HATBORO

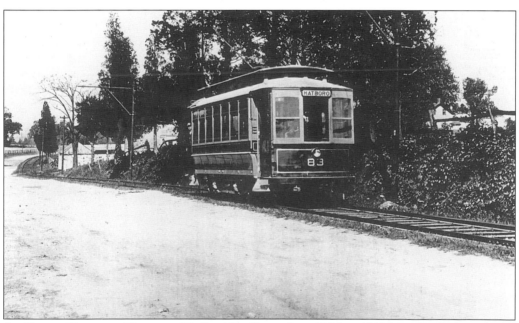

**AN EARLY HATBORO TROLLEY.** Trolley No. 83 ran from 1910 to 1918 between Willow Grove and Hatboro. It came up from Willow Grove, north on Easton Road (Route 611), to where the turnpike entrance is now. It then crossed over to Horsham Road by way of Easton Road, Hatboro Avenue, and Moreboro Road. There, the trolley turned right onto Horsham Road and left onto York Road. It traveled north a few blocks before stopping at what was later Burdick's Hatboro News Agency.

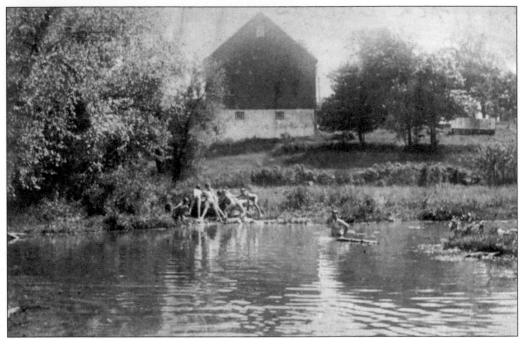

**PENNYPACK BATHERS.** In the background is the Fulmor Mill built in 1883. It was located on Mill Street and Warminster Road in Upper Moreland Township. It was sold to W.W. Walsh in 1892. A fire destroyed it in 1914. Mill Street was later renamed Fulmor Avenue

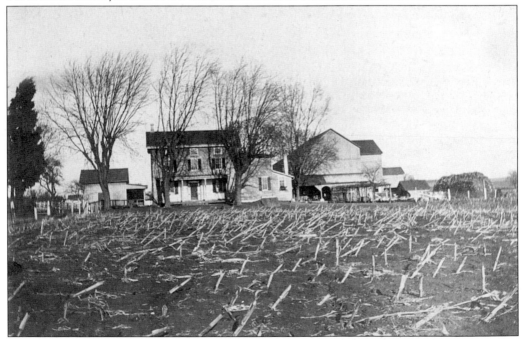

**THE HARRIS WEBSTER FARM.** This picture taken in 1903 is of the Harris Webster Farm. The property is typical of the small family farms that surrounded Hatboro and, in some cases, were located on York Road. These farms were well kept and the buildings were generally of stone or frame and stone.

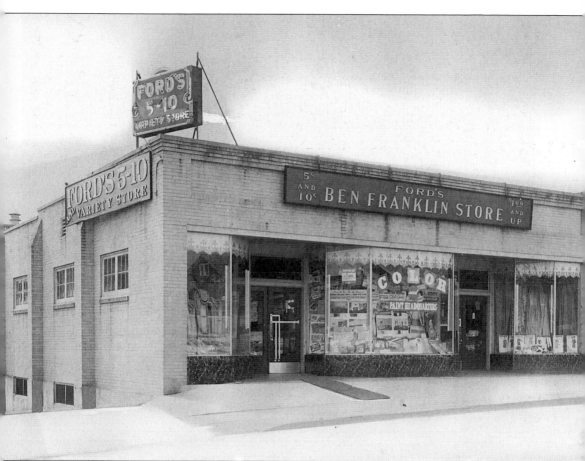

**FORD'S BEN FRANKLIN STORE.** This business was later transferred to York Road. However, at the time this picture was taken, it was located on the south side of Williams Lane, near York Road. Ford's was a variety store much like a Five and Ten or a Woolworth's. It preceded the Woolworth store, which was built in the 1950s on the corner of York and Williams Lane, directly across the street from this building.

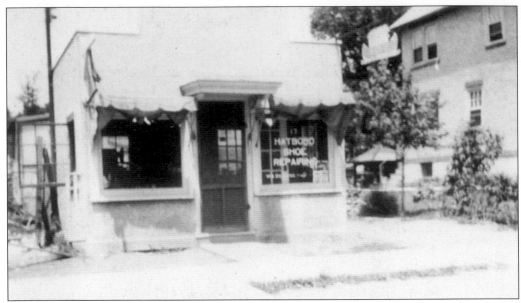

**BEIFUSS SHOE REPAIR.** In July 1928, William Beifuss came to Hatboro on the trolley car looking for work as a shoe repairman. Instead of working for someone else, he purchased a shoe repair business located on York Road. It was moved to Byberry Road shortly thereafter. He married his wife, Anna, in May of 1929, and they had two sons who worked in the trade. The younger son, Ronald, still runs the family business. By 1950, the original building became too small and a new building was erected. The business is one of the oldest in Hatboro still in family hands.

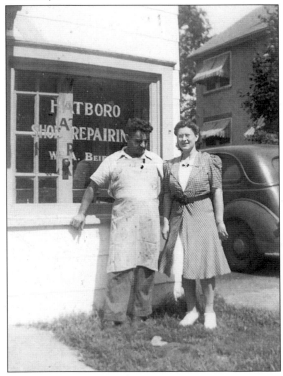

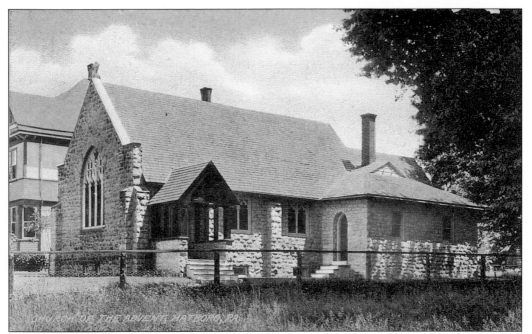

**THE CHURCH OF THE ADVENT.** The Protestant Episcopal Church of the Advent was built in 1904 on Byberry Road. At the time this photograph was taken, it was the newest church in Hatboro. In 1929, the church constructed a parish home.

**BYBERRY ROAD.** This view, which was taken looking east, shows the fine and stately homes that were built along Byberry Road, most of which are still standing. Currently, the Enterprise Fire Company is located on the south side. Byberry Road ran east to the Byberry Friends Meetinghouse, the first in the area. This early road connected at the York Road Pennypack Bridge west to the Horsham Meetinghouse and Easton Road, allowing a communication of the two meetinghouses.

THE SAMUEL J. GARNER RESIDENCE. This home located on Byberry Road was built *c.* 1872. It was later occupied by Samuel J. Garner's son S. Carl Garner, who lived in it for many years. The son owned and operated the Garner lumber company on South York Road.

DR. PAUL H. MARKLEY'S RESIDENCE. This home on Byberry Road later became the site of the Enterprise Fire Company. Note that Byberry Road was just a dirt road at the time of this picture. Well-to-do residents and professionals lived on the south side of Byberry Road; blue-collar workers lived on the north side. At one time, this building was owned by Dr. Carroll.

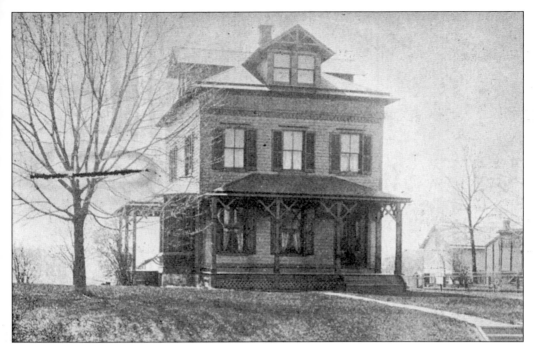

THE JAMES VAN HORN RESIDENCE. This home located on Byberry Road was built between 1870 and 1890. A square-shaped tower was added to the building after this picture was taken.

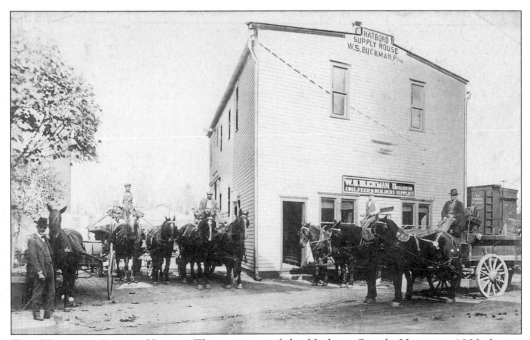

THE HATBORO SUPPLY HOUSE. This image is of the Hatboro Supply House, c. 1900. It was owned by W.S. Buchmann. This was one of Hatboro's three lumberyards. Going east on Moreland Avenue, it was in the second block from York Road.

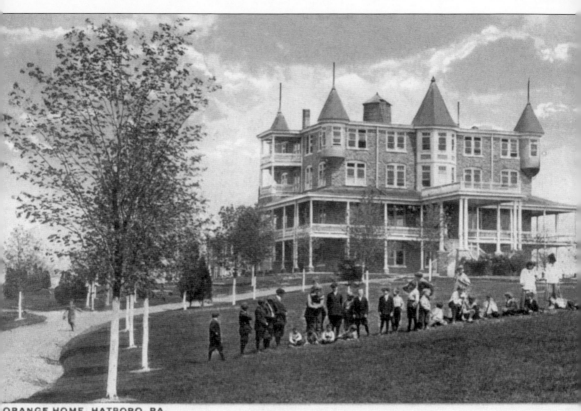

ORANGE HOME, HATBORO, PA.

**THE ORANGE HOME.** Although it was first built as a home for orphans at the beginning of the 20th century, the Orange Home served increasingly for the elderly of the Loyal Order of Orangemen. In 1995, it became the property of Maple Village, which is managed by the Evangelical Manor, related to the Eastern Pennsylvania Conference of the United Methodist Church. The original structure can still be seen today, even with the recent extensive nursing additions on the north and west. Situated around the home are pleasant, two-family living quarters for the elderly.

**A 68-ACRE PARCEL.** Over 100 years ago, the Orange Home was started by Rev. George Worrel, a native of Northern Ireland, to house both retired people and orphans. Worrel, the original president of the Loyal Orangemen of the United States, in 1901 purchased the 68 acres along Byberry Road. Through this organization, he raised $15,000 to buy this parcel, known as the Osborne Farm, from the Ritchie and Rhoades estate. The 42-room, four-story granite building was completed in 1903. It was built for the orphans of deceased members of the Loyal Orangemen and for "our aging and infirm brethren." It was turned into a retirement home in 1957. Where sheep once grazed, the Wynfair Apartments for the retired now stand.

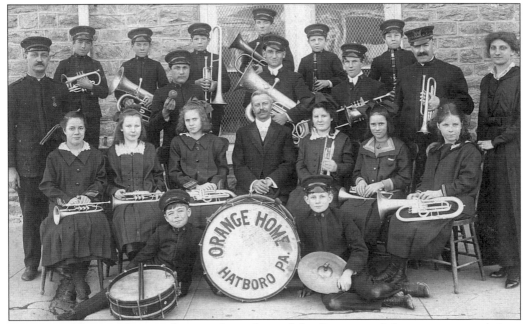

**THE HOME BAND.** These orphans and members of the Orangeman's home constituted their own band and possibly marched in an annual parade. Every Labor Day a special train came to Hatboro for the Orangeman's parade. It carried the bagpipers and other musicians, as well as day visitors. The annual parade was a big event in Hatboro.

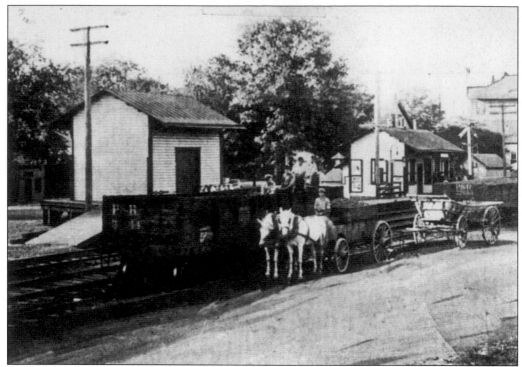

THE OLD HATBORO TRAIN STATION. This is another view of the old Hatboro Train Station, showing the station house and baggage or freight building. Note the coal car with men shoveling coal into the waiting delivery wagon. The new station stands in the same location, but the freight station was removed *c.* 1998 to make room for more parking spaces.

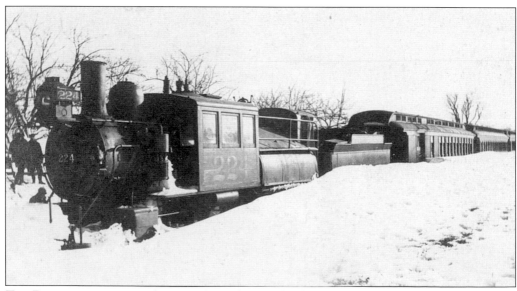

THE BLIZZARD OF 1912. This train from Philadelphia became stranded in the railroad cut east of Hatboro. Passengers were taken off the train by local citizens using sleighs. The picture shows a camel-back steam locomotive.

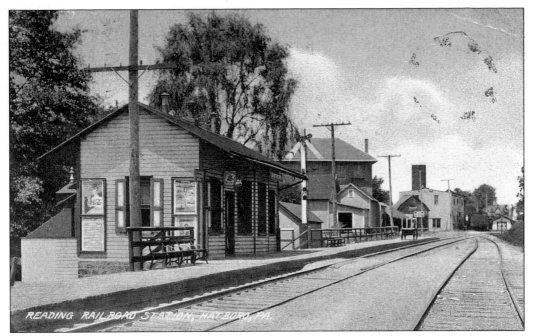

**THE WOODEN DEPOT.** This wooden structure was replaced in 1935 by a larger stone station house, which still stands. Note the semaphore arms to the right of the building for signaling the train engineer. Out of the picture to the left, is a small freight building that stood until *c.* 1998. By the 1930s, the rail line had become electrified. The large building in the distance on the right is the W.K. Bray Masonic Lodge, which still stands.

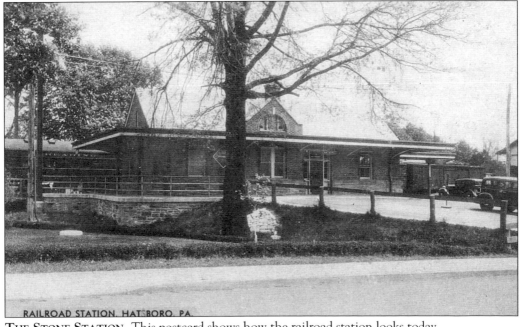

**THE STONE STATION.** This postcard shows how the railroad station looks today.

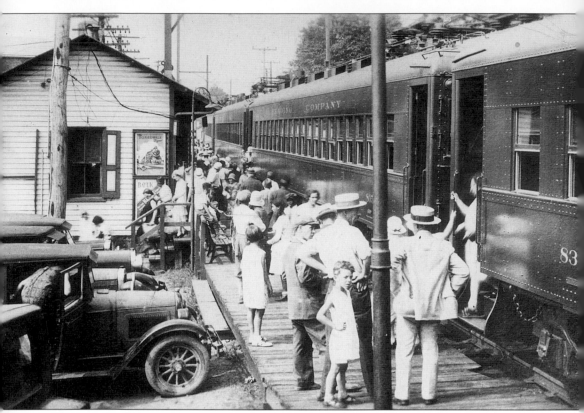

**HATBORO'S FIRST ELECTRIC TRAIN.** The first electric train is shown with passengers disembarking at the Hatboro Station in the early 1930s. Ticket agent K. Patterson is the man wearing a hat on the left in the foreground. The man on the right is Seth C. Van Pelt, and the boy is Robert Van Pelt. Note the old wooden ticket office that predated the present one.

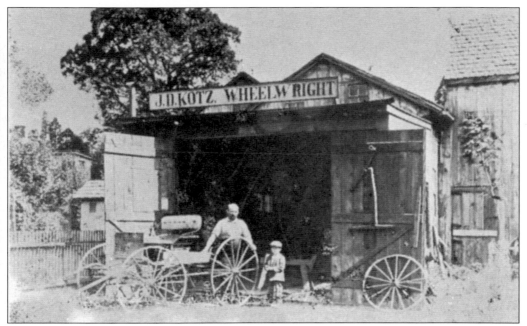

**JOHN KOTZ, WHEELWRIGHT.** This item is John Kotz's wheelwright shop, which was at the corner of Montgomery Avenue and York Road. A dual-purpose shop, it was also the home of Hatboro's first movie theater in 1908. Kotz put benches up inside his shop and showed silent films on a very early projector. He charged one penny for people to come in and see the program.

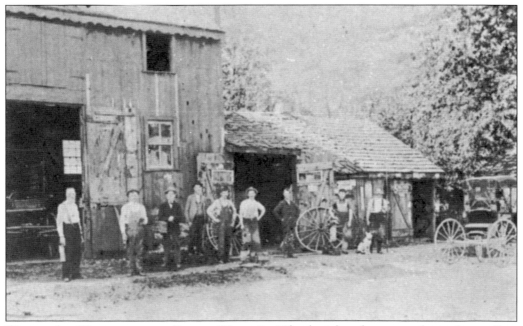

**WATSON'S WHEELWRIGHT SHOP.** Watson's Wheelwright shop was located on East Montgomery Avenue just off York Road in 1908. When H and R Auto Radio broke ground for a three-bay garage there, bottles, glass shards, and other trash was uncovered at the site.

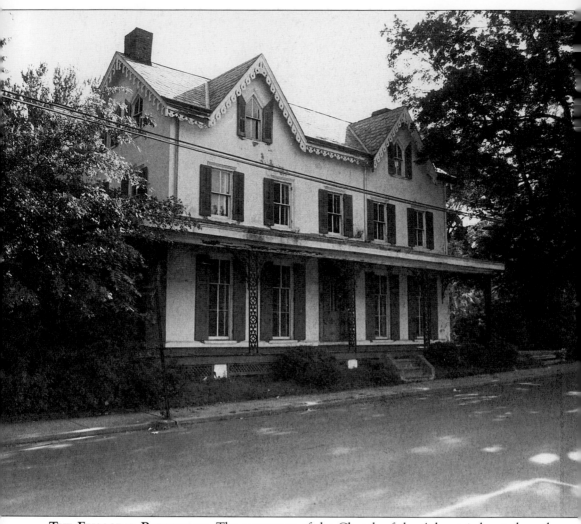

**THE EPISCOPAL PARSONAGE.** The parsonage of the Church of the Advent is located on the corner of Penn Street and East Moreland Avenue. It was built in stages, as were many churches in Hatboro. Colonial, Federal, Gothic Revival, and Victorian periods all are represented. The oldest section dates to the late 1700s. Some of the original work is still visible.

**THE FURNITURE STORE.** Not all postcards have horses and wagons, fire trucks, cars, or airplanes pictured on them. This card shows a quiet neighborhood at Penn and Moreland in the early part of the 1900s. Cards such as this one were purchased by the area residents to send to their friends. Bowe's Unpainted Furniture Store is on the right in the foreground, in a building that later became a a professional office.

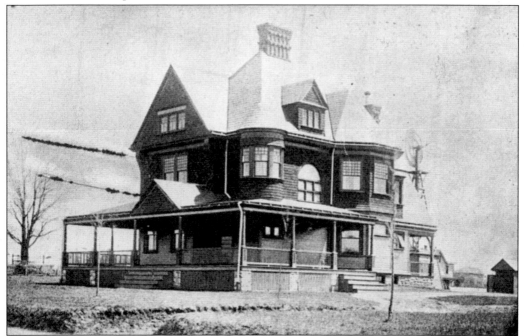

**THE COMLY WALTON RESIDENCE.** Situated on the corner of New Road and East Moreland Avenue, this home is one of the finest examples of Victorian architecture in Hatboro. It still stands but has been modernized so much that it cannot be recognized as it appears here.

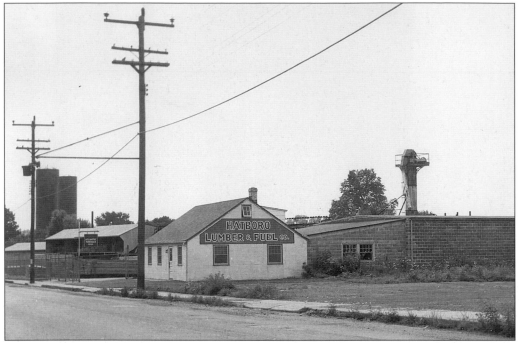

THE HATBORO LUMBER AND FUEL COMPANY. This building was, and still is, located on Jacksonville Road. Note the two borough water towers at the Hatboro Water Authority on Montgomery Avenue.

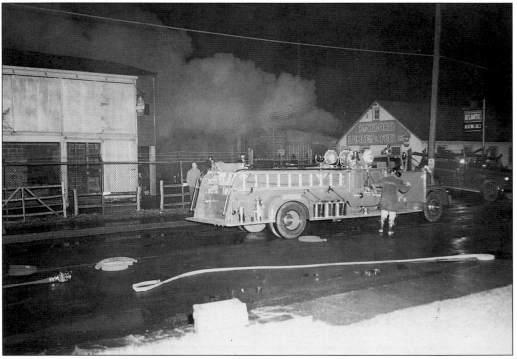

THE LUMBER COMPANY FIRE. On January 29, 1957, a fire at the Hatboro Lumber Company caused $100,000 damage.

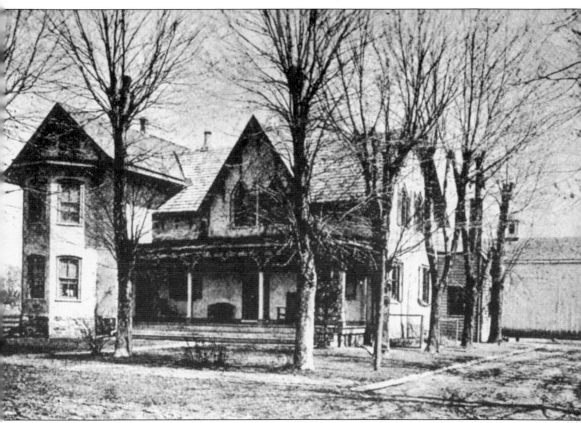

**THE HONORABLE ARTHUR D. MARKLEY'S RESIDENCE.** This is an 1892 picture of the Markley residence, which stood on Northampton Street (now Jacksonville Road), where the Milford Rivet Company was later located. This property was advertised in the *1892 Real Estate Book* as the home owned by Jonathan T. Rorer, formerly the Longstreth home.

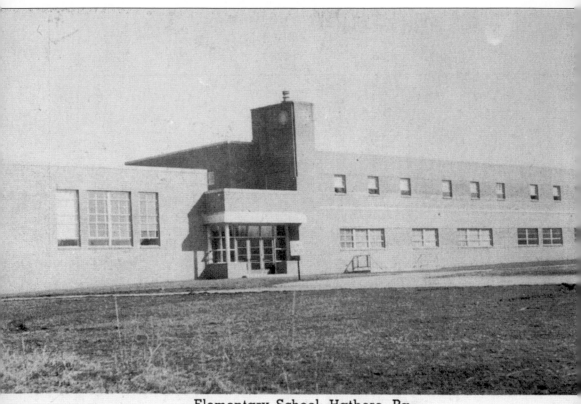

Elementary School, Hatboro, Pa.

**CROOKED BILLET ELEMENTARY SCHOOL.** At the time this picture was taken, this school was known as Meadowbrook Elementary School, located on Meadowbrook Avenue. The Crooked Billet battle monument, which once stood on the east side of York Road on an island in Monument Avenue, was later located in the front yard of this building. This school was built in the early 1950s to alleviate overcrowding at the Loller Academy. It was later enlarged in several stages. Crooked Billet Elementary School remains the only school known to stand on the site of a Revolutionary War battlefield. The monument was moved here and rededicated in the spring of 1967.

# Five

# Willow Grove
# and Horsham

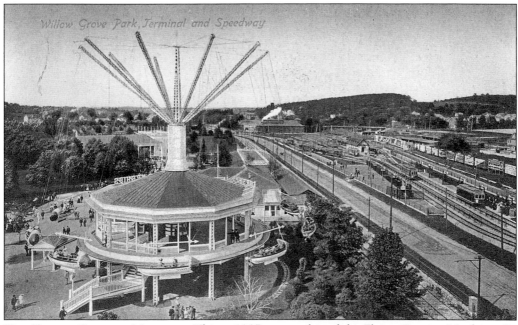

**THE FLYING CAPTIVE MACHINE.** This *c.* 1907 postcard is of the Flying Captive Machine. In later years, it was called the Rocket Ship. The road at the right is Easton Road with the trolley terminal, the final stop of the trolley lines. People flocked into the park to ride the flying ships and the roller coasters and to have a wonderful and memorable day.

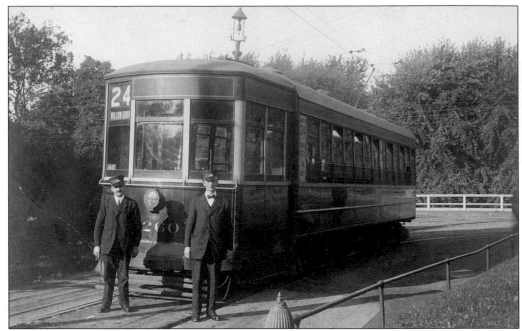

**TROLLEY NO. 24.** This real photo postcard of the Willow Grove Terminal was taken in the 1920s, with the conductor and motorman posing at the end of the run. The trolley came to Willow Grove from Philadelphia, bringing people to work and to Willow Grove Park. Trolleys also ran from here to Hatboro and to Doylestown.

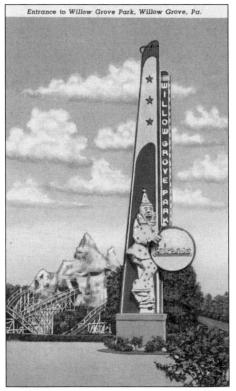

Entrance to Willow Grove Park, Willow Grove, Pa.

**PARK SIGN.** This sign stood at Easton and Welsh Roads as a welcome to families driving to Willow Grove Park. The clown on the sign was the first sight that came into view. Behind it, young and old alike experienced happy and marvelous times. They brought a picnic lunch, went on amusement rides, played games, and enjoyed the freak shows and musical programs. Normally, even when they got tired and went home, park visitors could not wait to come again.

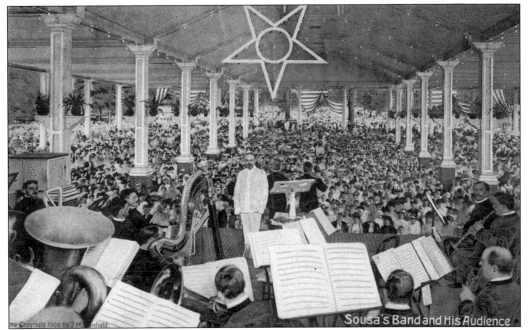

**SOUSA'S FIRST SEASON.** John Phillips Sousa's first season at Willow Grove Park was in 1901. His last performance was in 1926. Six years later he died. He played to crowds of up to 17,000 people at a concert in the afternoon and then again at night during the season. Reportedly some 100,000 people came to his final concert, and the last piece he played was "Stars And Stripes Forever."

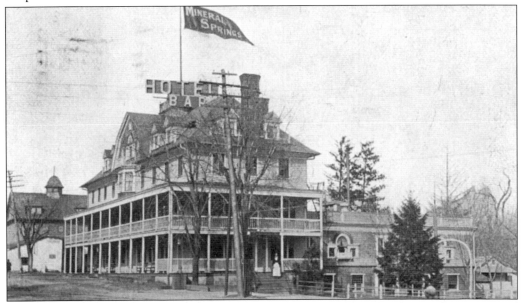

**THE MINERAL SPRINGS HOTEL.** This hotel in Willow Grove became famous for its mineral water. Named Mineral Springs in 1811, the hotel was known to have a fine ballroom. More hotels followed in 1872, after the railroad came in from Philadelphia. The Willow Grove Historical Society has uncovered china from this establishment. Today, a fitness center and parking lot occupy the site.

**GREETINGS FROM HORSHAM.** Horsham was a small, early farming community located west of the town of Hatboro. Like many of the surrounding communities, high school students from Horsham went to Hatboro High School. In 1942, the navy bought the flying field of Harold Pitcairn on Easton Road in Horsham, and it became the a U.S. Naval Air Station. The station used Willow Grove as an address for postal reasons. Horsham has since become a bustling community and in the 1950s, it became a joint school district with Hatboro. A new high school was later built on Route 463 (Horsham Road) in Horsham.

**A GRAND OLD SASSAFRAS TREE.** This mammoth old tree is in the Horsham Friends Graveyard. When the first settlers came to this area, it must have been a large tree of over 100 years. When this picture was taken, the tree had survived 360 years in its very peaceful surroundings. But, alas, it is no more. The was hit during a lighting storm in 1942. For years a 15-foot-tall vine covered the remains; then in 1990 a fire, reportedly set by vandals, destroyed the last remnants, leaving only a raised area to be seen today.

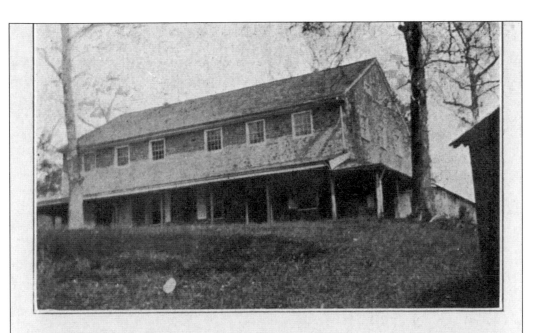

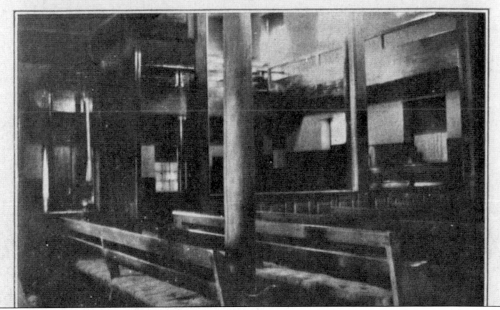

**THE HORSHAM FRIENDS MEETINGHOUSE.** This is a rare multi-view postcard showing both the interior and the exterior of the Horsham Friends Meetinghouse. The original meetinghouse was built in 1717, but was quickly outgrown. The present meetinghouse was built in 1803 across the street from the original on Easton Road. The meetinghouse resides on land donated for that purpose by Samuel Carpenter (the actual gift was made after his death by his widow, Hannah). He named his plantation Horsham, after his birthplace Horsham, Sussex, England. From this, the township derived its name. Easton Road, from where these exterior photos for the postcard were taken, was long known as Governors Road, as it took one to Governor Keith's Plantation in Horsham. The carriage house is intact. The interior shows the plain decor of the Quaker meetinghouses.

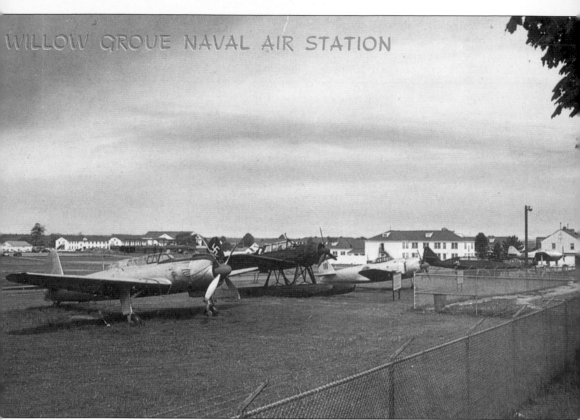

**WILLOW GROVE NAVAL AIR STATION.** After World War II, the navy acquired captured enemy aircraft for display along Route 611 (Easton Road). The pictured airplanes, from left to right, are a Japanese torpedo dive bomber; a German sea plane, used for reconnaissance; a Japanese fighter airplane; a German ME 262 fighter, the first jet plane used in combat; and a Japanese sea plane. A fifth airplane, second from the right, that cannot be clearly seen, is believed to be a U.S. Army Curtiss P 40.

**STABLE MABLE.** This one-man helicopter was called "Stable Mable." It was built for the Office of Naval Research and the U.S. Army by Kellett Aircraft Corporation of Horsham. It got its name for its extreme stability and maneuverability, using a new gyro-stabilizing system devised by Kellett. The single-place, rocket-powered craft, weighing only 230 pounds empty and 640 pounds in flight, used hydrogen peroxide fuel. For a time the Philadelphia National Bank at Broad and Chestnut Streets publicly displayed Mable in their main office lobby.

**A WORLD WAR I JENNY.** This is a picture of Al Winner, postmaster of Hatboro, standing beside a Jenny of World War I vintage. It was used as an airmail plane.

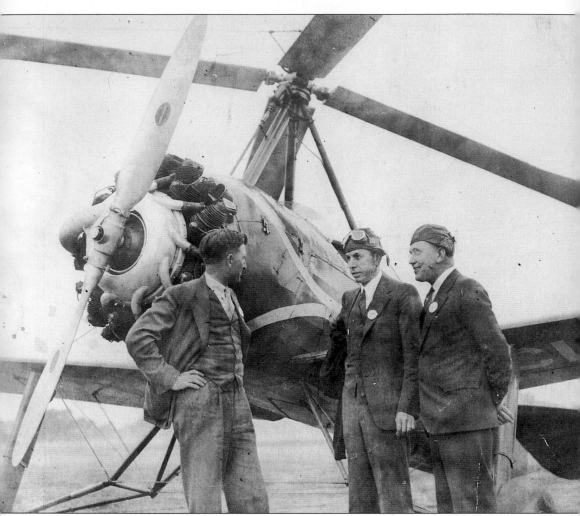

**PITCAIRN AIRCRAFT.** Shown in the picture are, from left to right, H. Pitcairn, the pilot; Al Winner, the postmaster of Hatboro; and W. Knipe, the postmaster of Horsham. The original company was named the Pitcairn Aircraft Company. Harold F. Pitcairn was the sole owner and started airmail delivery routes along the eastern seaboard in 1928. The routes became those of Eastern Air Lines. In the 1930s, the company shifted its interest to autogyros and was called the Pitcairn Autogyro Company. It was the company to develop and fly autogyros in the United States. During World War II, the company was called G and A Aircraft Inc. of Horsham.

# Six

# BUCKS COUNTY

## WARMINSTER, JOHNSVILLE,
## WARWICK, HARTSVILLE, DAVISVILLE,
## AND SOUTHAMPTON

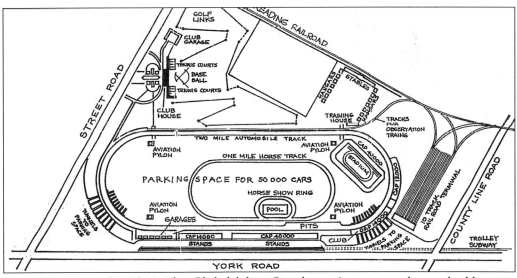

THE SPEEDWAY. In 1914, the Philadelphia Speedway Association began building an automobile racetrack. Plans called for a 2-mile track from County Line Road to Street Road and from Park Avenue to York Road. Construction was halted by World War I and was never resumed. Today, there are still some signs of the beginning construction. Homes occupy this this land today. It is still referred to as the Speedway Section in the township of Warminster. The drawing is an engineer's plan of the vast complex.

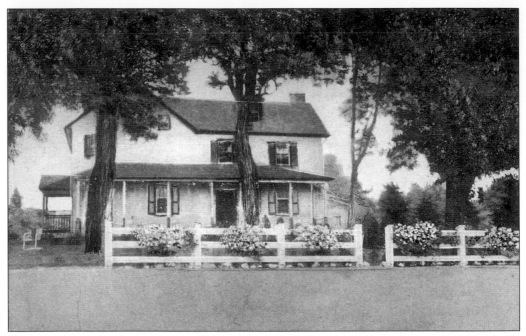

**THE OLD FIRESIDE RESTAURANT.** Built in the early 1700s, this was the home of Job Noble. In later years it became a restaurant, which advertised to "cater to parties and banquets and all social affairs." Its telephone number was Hatboro 9689." Demolished in the early 1960s, the restaurant has been replaced by Altomonties Italian Deli.

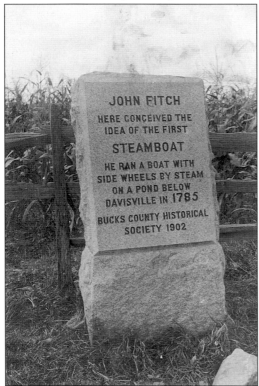

**THE JOHN FITCH MONUMENT.** Shown is a monument in Warminster dedicated to the memory of John Fitch, who first conceived the idea of the steamboat. He made a model craft and engine which worked oars to propel the craft. He tested the model on Longstreth's pond, located at Davisville and Street Roads. A clock maker, Fitch concentrated his efforts on this watercraft. In 1790, he built a couple of steamships that traveled 8 miles per hour and served as ferries on the Delaware River, carrying people from Trenton to Philadelphia.

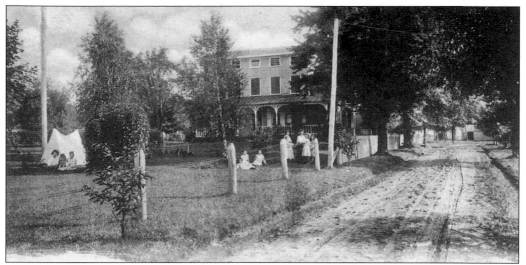

**ST. STEPHEN'S FARM.** Ask 100 people where St. Stephen's Farm was and you would receive 100 "I don't know" answers. John C. Beans is reported to have had a school on the property when he owned it in the 1820s. Samuel Emlen moved his school for orphan children of Native American and African-American descent to the farm from 1872 to 1892. When an Episcopalian charity took it over in 1897, it became known as St. Stephen's Orphanage. St. Stephen's, though organized in Ohio in 1841, moved to a 50-acre farm in Solebury, Bucks County, and then to this Warminster farm. Lastly, the farm, west of York Road and along the south side of Street Road, was owned by Christ's Home for the Aged until Kohl's Department Store and the Warminster Town Square Mall were built on the property, c. 1997.

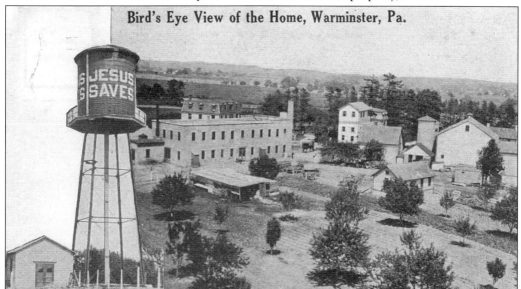

**CHRIST'S HOME.** This is a bird's-eye view of Christ's Home for children. Inset in the image is the well house and water tank. The institution was founded by Dr. Albert Oetinger in Warminster c. 1907 as a home for children, the aged, and missionaries who rested here before returning to the mission field. Typical for its time, the home was completely self-sufficient, with its own kitchens, bakery, laundry, gardens, farm animals, schoolhouse, and chapel. It even had shops for shoe repair and printing.

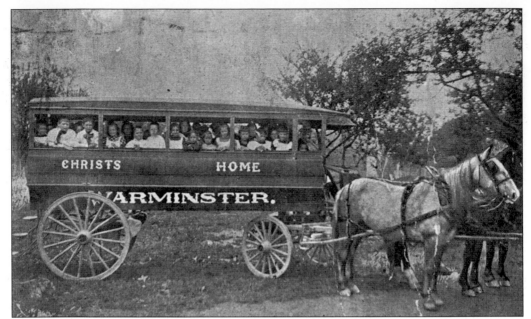

**CHRIST'S HOME TRANSPORT.** This postcard view shows a horse-drawn lorry of students attending Christ's Home. Pictured *c.* 1910, this postcard was in black and white, as were most of the Christ's Home's cards that were printed before 1950. A group of chrome cards was produced *c.* 1960, showing the various work areas at the home. By then, the home no longer had its own cows, chickens, or vast gardens. Christ's Home still serves the Christian community in much the same way as it did in 1907.

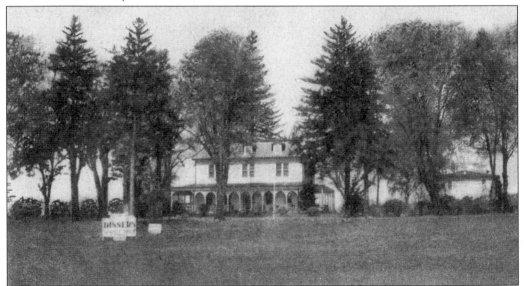

**THE ROSELAND INN.** This inn on Old York Road, Hartsville, Bucks County, was formally known as the Classical School For Boys but later became the Roseland School For Girls. Built *c.* 1832, the school was started by Rev. James P. Wilson and existed for about eight years. The building then became an inn called Duffy's Inn and lastly, the Hartsville Inn. During the late 1990s, the building hosted the local children as a Halloween-time haunted house. The building is scheduled for demolition.

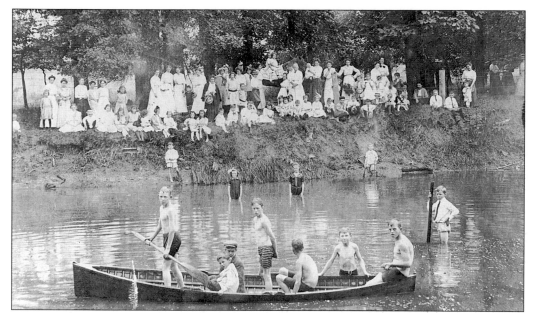

**SUNDAY SCHOOL PICNIC, 1915.** The Hatboro Baptist Church Sunday school enjoys a picnic in Darrah's Woods along the Neshaminy Creek in Hartsville, near the Warwick Presbyterian Church. The children are, from left to right, Walter Craven, Earl Yerkes, Ruth Walton, Helen Craven, Henry Laughlin, Noreen Hilt, Dorothy Gallagher, and William Starrett.

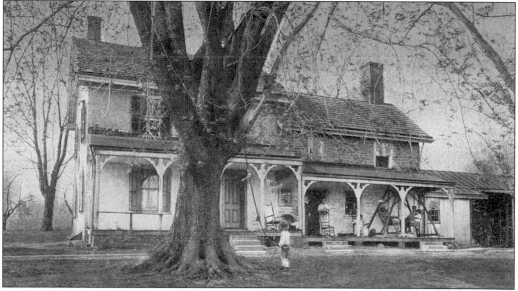

**WASHINGTON'S NESHAMINY HEADQUARTERS.** This headquarters farm, currently known as the Moland House, is situated on Old York Road in Hartsville. It was built in 1740 and purchased by John Moland in 1759. The widow Moland rented the house to Gen. George Washington during his 13-day stay with 13,000 troops at the crossroads. It was here where a council of war met, attended by Washington, four major generals, seven brigadier generals, and many additional officers. It was also here that a later-adopted 13-star flag first flew over land, and where General Lafayette joined the Revolutionary Army. The building is being restored, and an archeological excavation taking place.

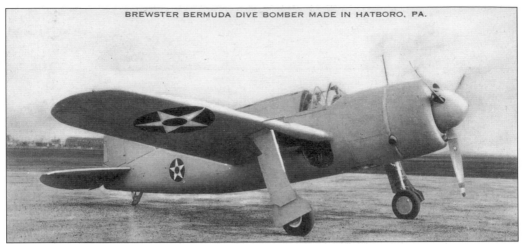

**BREWSTER BERMUDA DIVE BOMBER.** This airplane is a Brewster SB2A Buccaneer dive bomber. It first flew in 1941. The SB2A suffered from design and production problems, so its life was short. There were only 771 of these produced for the U.S. Navy and the English government. The British version of the SB2A was called the Bermuda. Neither saw combat.

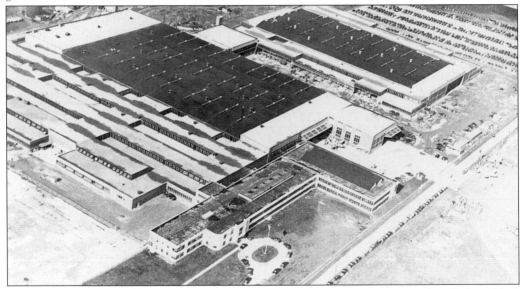

**BREWSTER AIRCRAFT PLANT, JOHNSVILLE.** The Brewster Company was founded in 1810 to make horse carriages and in the 1900s, the company made automobile bodies. In the 1930s, it manufactured seaplane floats, tail surfaces, and wing surfaces at its Long Island City, New York and Newark, New Jersey plants. In 1939, Brewster purchased land in Johnsville to build a new plant, as the Long Island and Newark plants were inadequate. A contract in 1943 was awarded to Brewster to build the F3A Corsair fighter aircraft for the navy. After manufacturing 735 Corsairs, labor troubles forced the navy to terminate the contact on July l, 1944. The navy took over the airfield and plant, and moved in the Naval Air Modification Unit. Later, in 1947, it became the Naval Air Warfare Center, and lastly, the Naval Air Development Center in 1992. A large centrifuge to simulate the effect of G-forces on the human body was built on the site to train the early astronauts. By 1993, the center was nearly closed and most of its operations were moved to the Patuxant River Naval Air Station. The base was completely closed a few years later.

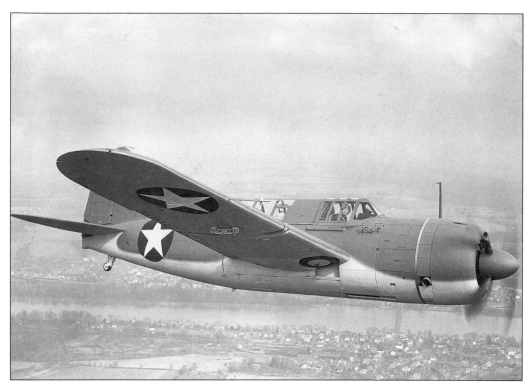

**A BREWSTER BUCCANEER.** With the outbreak of war in Europe, Brewster received a contract to manufacture SB2A Buccaneer Scout bombers for the navy. The SB2A first flew in 1941, but it never flew in combat.

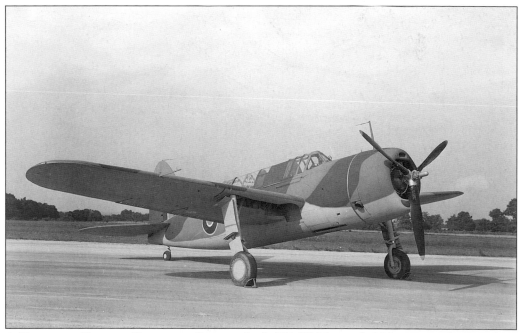

**A BREWSTER BRITISH BERMUDA.** Brewster built 771 SB2As, with 306 going to the British as the Bermuda. The navy relegated the SB2As for training.

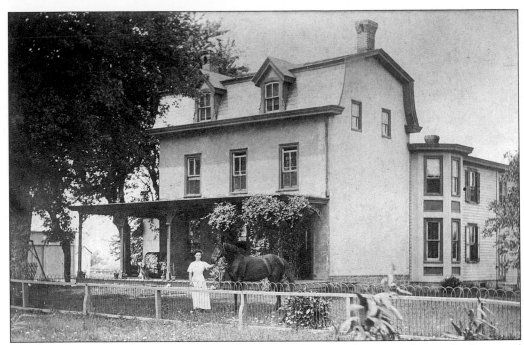

**THE CARRIE YERKES CARTER HOME.** In this picture, Carrie Yerkes is standing in the front yard holding her favorite bay mare. This house is located on the west side of Newtown Road in Warminster Township just below the hospital.

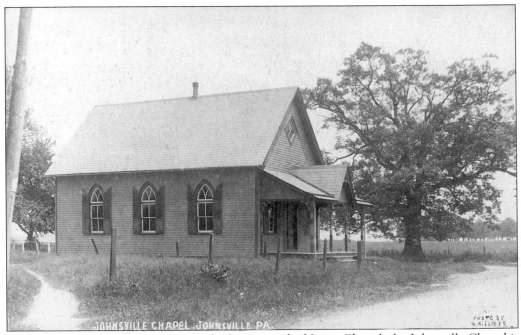

**JOHNSVILLE CHAPEL, JOHNSVILLE.** Also known as the Union Chapel, the Johnsville Chapel is at the corner of Street and Newtown Roads. It was built in 1898 at a cost of $1,036.98. Services were held here until 1952. It then became a community center, and many community organizations met here. It is currently an engineering firm office.

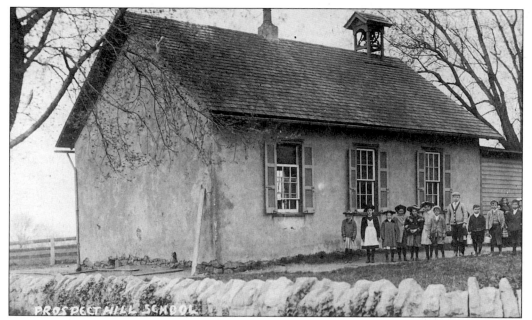

**THE PROSPECT HILL SCHOOL, JOHNSVILLE.** This school is at the top of Davisville Hill on Street Road. It served as a truly united Sunday school, for in 1882, under the auspices of the Davisville Baptist and the Southampton Reformed Churches, it also received about 50 volumes from the Presbyterian Board of Publications to start a library. There were several early schools in the area, producing many fine scholars who went on to renown in education throughout America.

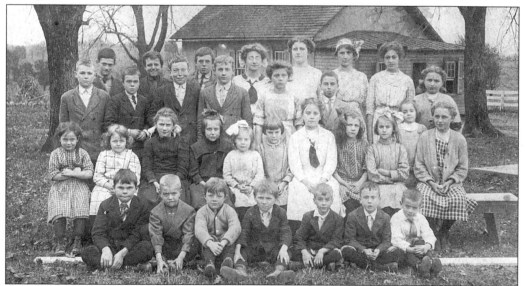

**THE WARMINSTER PROSPECT HILL SCHOOL.** Shown in this photo are, from left to right, the following: (first row) John Wilson, Bob Longhead, two unidentified students, and Jim Longhead; (second row) unidentified students; (third row) John Valentine, Nate Houk, Paul Bennett, Ben Valentine, Edith Yerkes, Charles Longhead, and Hazel Myers; (fourth row) Mr. Duncan, Norman Pearson, one unidentified student, Stella Potts, teacher Vallie Williams , Florence Bussinger, Miss Moore, and Emma Fismire.

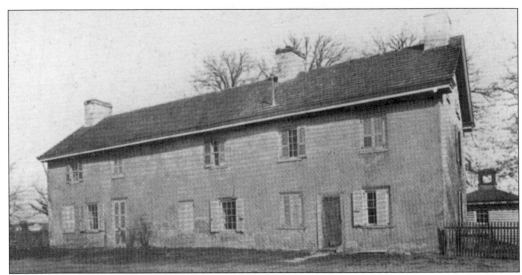

**THE CRAVEN-FINNEY FARM.** The farm shown is located near the intersection of Jacksonville and County Line Roads in Warminster Township. At the time the picture was taken, the area was considered a part of Hatboro, and the farm was owned by I. Newton Finney. Part of the Revolutionary War Battle of Crooked Billet was fought here on May 2, 1778. In late 1943, a war housing project to accommodate workers of the Brewster Aeronautical Corporation, Johnsville division, was constructed on the Finney Farm. Lacey Park, as it was called, was a community of 1,200 homes, and was named after the Revolutionary War hero Gen. John Lacey, who commanded the troops at the Battle of Crooked Billet. The housing project was to include a water-pumping station, recreational facilities, a school to accommodate 600 pupils, and two day-care nurseries. Although the buildings were intended to be temporary housing, many are still standing and are occupied today.

**THE DAVISVILLE BAPTIST CHURCH.** In the very early days of Hatboro, churchgoers had three choices: the Horsham Friends Meetinghouse in Horsham, the Warwick Presbyterian Church in Hartsville, or the Davisville Baptist Church on the north side of Street Road, just east of Davisville Road. This is the original Davisville Baptist Church c. 1900. It was organized in 1849 with only 33 members.